The DR Art School

AN INTRODUCTION TO DRAWING

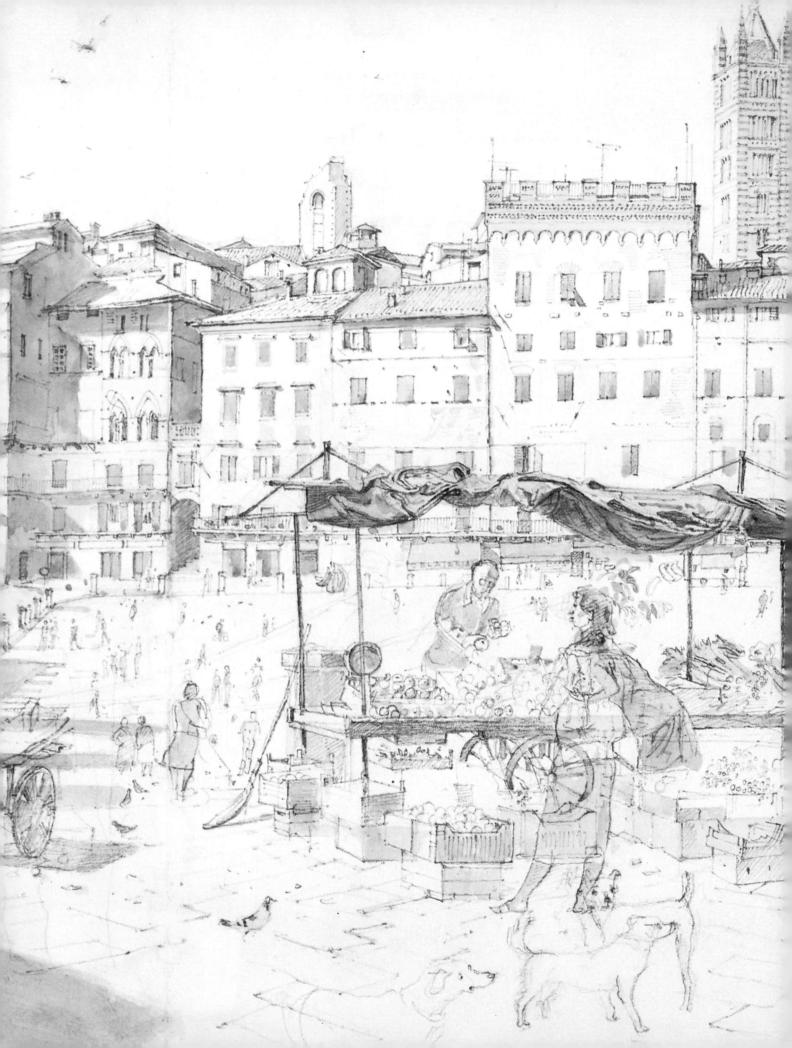

The M Art School

AN INTRODUCTION TO DRAWING

JAMES HORTON

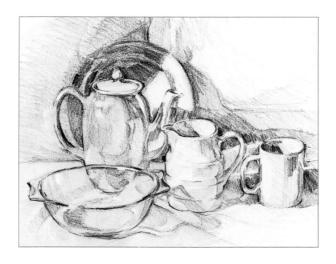

DORLING KINDERSLEY London • New York • Sydney • Moscow www.dk.com

IN ASSOCIATION WITH THE ROYAL ACADEMY OF ARTS

A DORLING KINDERSLEY BOOK

www.dk.com

Project editor Susannah Steel
Art editor Heather McCarry
Designer Dawn Terrey
Assistant editor Margaret Chang
Series editor Emma Foa
DTP designer Zirrinia Austin
Managing editor Sean Moore
Managing art editor Toni Kay
Production controller Helen Creeke
Photography Steve Gorton,
Andy Crawford, and Tim Ridley

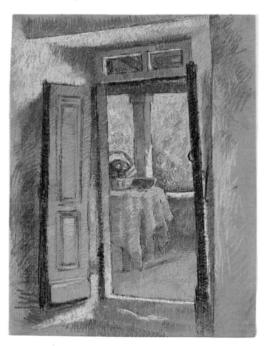

This DK Art School /Art book first published in Great Britain in 1994 by Dorling Kindersley Limited, 80 Strand, London WC2R ORL 4 6 8 10 9 7 5 3

Copyright © 1994

Dorling Kindersley Limited, London

All rights reserved. No part of this publication may be reproduced, stored in a retrieval system, or transmitted in any form or by any means, electronic, mechanical, photocopying, recording, or otherwise, without the prior written permission of the copyright owner.

ISBN 0 7513 0647 9

Colour reproduction by Colourscan in Singapore Printed and bound by Toppan in China

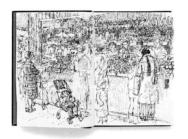

<u>Contents</u>

Drawing	6
A Brief History	8
Materials	
Pencils & Coloured Pencils	12
Pens & Inks	14
Chalks & Charcoal	16
Pastel Types	18
Watercolour	20
Gallery of Drawing Media	22
Paper	24
Gallery of Paper	26
Techniques	
Ways of Working	28
Getting Started	30
The Basics of Drawing	32
Linear Drawing	34
Form & Modelling	36
Tonal Drawing	38
Gallery of Form	40
Layout & Construction	42
Buildings & Architecture	44
Interiors & Exteriors	46
Gallery of Composition	48
Drawing Natural Forms	50
Landscapes	52
Gallery of Landscapes &	
Natural Forms	54
Figures & Drapery	56
Life Drawing	58
Portraits	60
Figures in a Setting	62
Gallery of Figures	64
Movements & Gestures	66
Drawing for Painting	68
Glossary	70
Index • Acknowledgements	72

DRAWING

As CHILDREN WE HAVE ALL DRAWN or painted, yet the older we become, the more we seem to ignore the significance of drawing as a vital source of communication and pleasure. Drawing is still one of the best ways to convey information directly, despite the increasing prevalence of photography. Scientists, and in particular archaeologists, actually prefer to

draw many items because a detailed drawing can be more precise and informative than a photograph, since it involves a process of selection. Most natural history field guides rely on detailed drawings and paintings for identification purposes.

The best approach

Drawing well is all about how you perceive the

world around you and interpret it into your own

personal vision.

As adults we see the world in a very different way to that of children. The stumbling block for many of us is that with a more mature perspective we have a much greater sense of what we think is correct and what is incorrect (although this is often widely misunderstood) and this can often create inhibitions. There is, however, nothing intrinsically mysterious about the mechanics of drawing and anyone can learn to draw if they adopt the best approach. Just as with any other subject you might tackle, practice is essential to achieve good results.

Interpreting what you see

Ultimately drawing has far more to do with learning to see perceptively than acquiring consummate skill with your hand. The quality of what you draw on paper all stems from your imagination and the way you choose to interpret what you see. Look discerningly at objects, consolidating all the information you see, to give your drawings a freshness and individuality. Don't be afraid either to repeat lines or marks until a drawing

Brief History

THE HISTORY OF DRAWING may be as old as the human race itself. Cave paintings have been discovered dating back as far as 10,000 years BC, so it seems that man has always been interested in making images. However it was during the Italian Renaissance that artists developed profound drawing skills and the art of drawing underpinned all other artistic disciplines.

ONE REASON WHY drawing was at such a high standard during this period was that it related directly to the great profession of painting; a sculptor or a painter had a distinguished position within society and good artists were constantly in work. Renaissance artists such as Michelangelo (1475-1564) employed numerous assistants and ran a large workshop to cope with the many commissions. Unfortunately most of the preparatory drawings these artists made for paintings which today we would regard as important in their own right - were destroyed once the project had been completed.

More importantly, finished drawings were presented to clients as proposals for commissioned portrait work. Holbein (1497/8-1543) once had the precarious task of making a suitable drawing of a potential wife for Henry VIII in order that she be approved by the English king.

Northern Europe

Away from the high, classical art of Italy, the Flemish painter Pieter Bruegel (1525-69) used drawing to depict the everyday world around him, and his realistic peasant scenes brought him great admiration. Bruegel was one of many artists in Holland and Flanders during the sixteenth and seventeenth centuries who cultivated a genre that was based upon the lives of ordinary people. Although this "Golden Age" of Dutch painting owed little to Italy,

Pontormo, Study for the Angel of the Annunciation, c. 1525-30, 391 x 215 cm (154 x 84 in) Pontormo is generally acknowledged to be one of the greatest Renaissance draughtsmen and was highly regarded for his portraits. This study, with

its subtle blend of chalk and wash, has a beautifully sensitive quality despite the solid form of the figure

and the flowing drapery that tumbles about him.

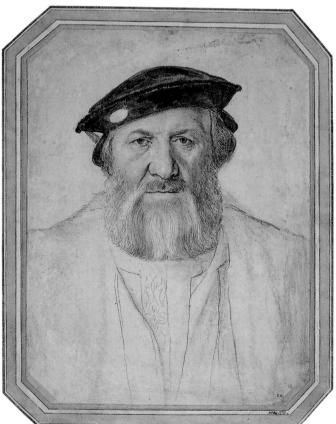

Hans Holbein, Charles de Solier, Sieur de Morette, c. 1534-35, 33 x 25 cm (13 x 10 in)

Holbein was often commissioned to do life-like portraits. His fine quality of line both flatters the features of this figure and lends him a heavy sense of authority.

an artist's training was based around figure drawing, which ultimately meant a pilgrimage to Italy.

One Dutch artist who never journeyed to Italy was Rembrandt (1606-69), who today is known particularly for his graphic work on

paper. As a portrait artist he avidly drew anyone who interested him, from old beggars to noblemen, with astonishing perception – often in his favourite medium of quill, brush, and bistre wash (a transparent brown pigment made from soot).

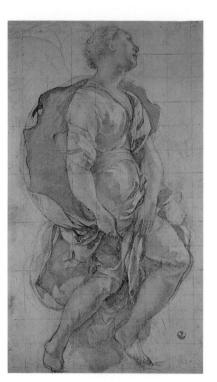

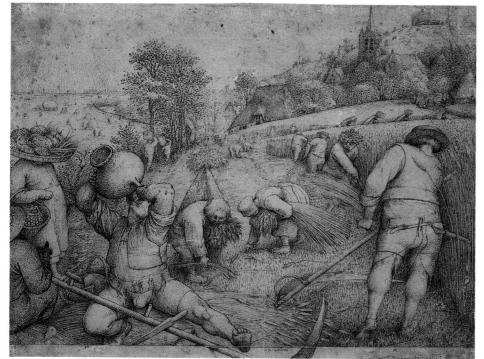

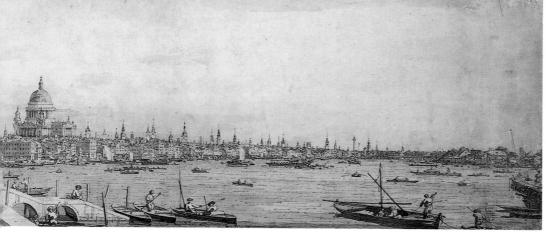

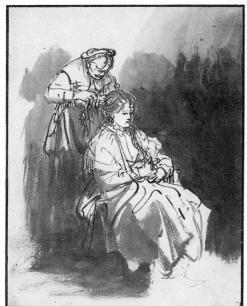

Canaletto, A View from Somerset Gardens Looking towards London Bridge, c. 1750, 60 x 185 cm (23½ x 73 in) Canaletto was renowned for his detailed paintings and drawings of architectural scenes. The wonderful clarity of this work has been achieved by drawing the panoramic composition in pencil and then overlaying it with brown ink and grey wash.

Rembrandt, Saskia at her Toilet, c. 1632-34, 24 x 18 cm (9½ x 7 in)
Rembrandt was often at his best when he recorded a fleeting moment in time. This drawing reflects the precision of his observant eye as he worked adeptly with first pen and ink, and then a loaded brush. The result is a drawing that is both lucid and evocative in its depiction of a domestic scene.

Pieter Bruegel the Elder,

Summer, 1568, 22 x 29 cm (8½ x 11½ in)
This beautifully drawn study of peasant life in
16th-century Flanders is actually rather formal
in its design, with the scythes of the two main
figures creating diagonals that lead the eye into
the middle and far distance of the composition.
Bruegel was also keen to convey a strong social
message in his humorous depiction of life.

Artistic contemporaries

Rembrandt's great artistic contemporary in neighbouring Flanders was Rubens (1577-1640). As a draughtsman, he was virtually unparalleled and was one of the few artists who appeared to make the process of drawing look easy. He drew copiously, working not only on preparatory studies for the vast amount of commissions he fulfilled, but also on a much more intimate

scale, depicting his family and servants with the freshness and immediacy that drawing promoted.

Curiously, some of the greatest figures of the seventeenth century such as Vermeer (1632-75), Caravaggio (1571-1610), and Velazquez (1599-1660), left little or no drawings. Although it is improbable that these artists never drew at all, it is more likely

that they preferred to solve their problems directly on the canvas in a painterly fashion.

Portrait drawing

Whilst not producing the giants of the previous century, the eighteenth century kept alive the commissioned portrait. In France, Watteau (1684-1721) produced fine studies of figures, heads, and drapery in his preferred medium of red, black, and white chalks, while in Italy Giambattista Tiepolo (1696-1770), arguably the greatest artist of his time, used pen and wash for his drawings that remain unrivalled to this day.

Pencil drawings

The nineteenth century saw a great surge in artistic development, which in England began with Turner (1775-1851) and Constable (1776-1837) and in France with Delacroix (1798-1863) and Ingres (1780-1867). Lead pencil was in use by this time and Constable used the medium to draw many small images of rural Suffolk in his sketchbooks with great subtlety and expression. Turner began to develop almost unbelievable powers of observation and skill in his youth as he drew cathedrals and buildings with a lead pencil.

Portrait drawings were still fashionable and studies drawn by the French Neo-Classicist Ingres were so real and lifelike that there was never any doubt as to their likeness to the sitter. Ingres' contemporary and great rival was Delacroix, who by contrast was a Romantic free spirit. He not only made studies in the traditional manner for grand historical pictures but also drew everything that caught his eye. In an age that preceded the advent of photography, drawing was the only way that Delacroix could record the trip he made to Morocco in 1832. Contemporary reports stated that he drew night and day, desperate not to forget the rich aspects of Arabian life.

The advent of modernity

Of the great draughtsmen of the nineteenth century, one innovative artist assimilated everything that went before him. This was Edgar Degas (1834-1917), whose life's work was based on drawing. Even as a middle-aged and well-established artist he copied works by other artists to stretch his understanding of art and practise his techniques. Degas' enormous output of drawings, pastels, monoprints, and etchings represents an incredible achievement, but by the time he died in 1917, the modern art

John Constable, Elm Trees in Old Hall Park, East Bergholt, 1817,

59 x 50 cm (23% x 19%in)
Unlike Turner, who used a wide variety of media in his drawings, Constable preferred to use his materials separately to describe the countryside around him. He used a pencil expertly to capture the organic growth of these elm trees with incredible detail so that they are easily recognizable.

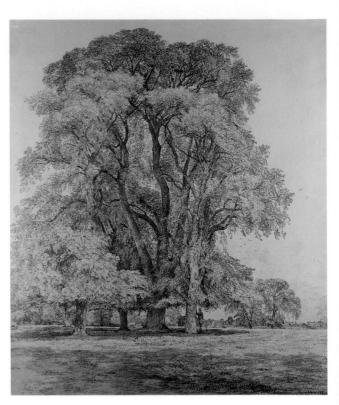

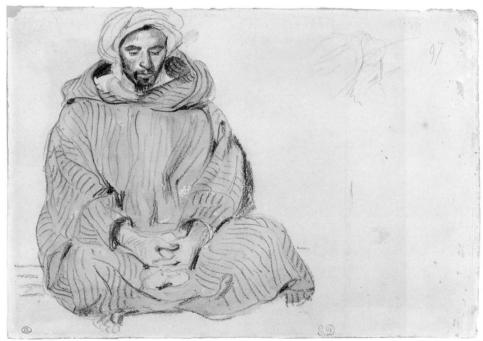

movement was well underway and moving rapidly towards a language that he would not have recognized.

The history of drawing from this point is a chequered one and it developed quite differently on either side of the English Channel. Whilst France pursued modernism, spurred on by artists such as Henri Matisse (1869-1954), England retained a basic

Eugène Delacroix, Seated Arab,

c. 1832, 38 x 46 cm (15 x 18 in)
This study is typical of the sketches Delacroix made during his Moroccan tour. He probably drew the figure hastily from life and added washes of watercolour later.

attachment to drawing. The turn of the century in England saw the birth of several major art schools, all of which placed a great emphasis on drawing, and although various modern

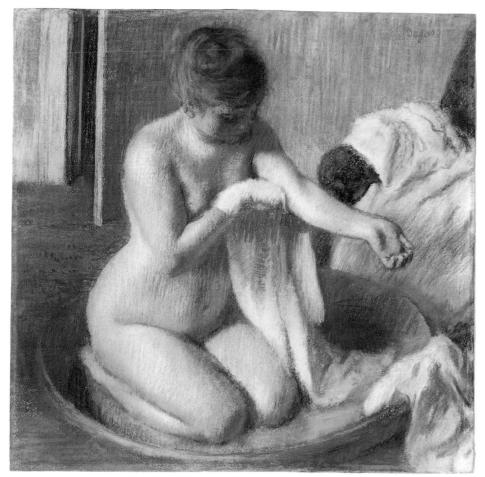

movements came and went, drawing continued to underpin students' training. The work of artists such as Augustus John (1878-1961) and later Stanley Spencer (1891-1959) bear witness to the significance of drawing in England through the turbulent years of the early twentieth century.

One artist who has brought drawing to the forefront of the contemporary imagination is David Hockney (b.1937). Inspired by Pablo Picasso (1881-1973), who had an extraordinary breadth of style and "was not limited by 'form'", Hockney takes pleasure in the lyricism and strength of pure line. Preferring the expressive beauty of drawings over more painterly approaches, Hockney has taken his art form to a far wider audience than ever before.

Edgar Degas, Woman in a Tub, c. 1885, 70 x 70 cm (27½ x 27½ in) Classically trained, Degas devised his own method of working with pastels. He built them up in layers, using strokes of colour that blended optically to give an extraordinary richness.

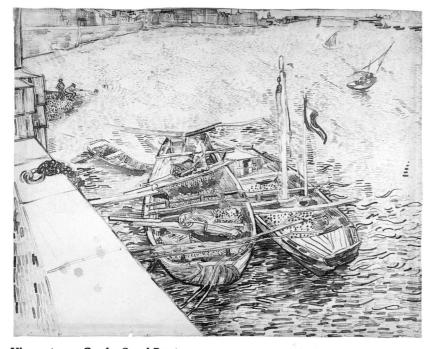

Vincent van Gogh, Sand Boats, 1888, 49 x 60 cm (19 x 23½ in)
Van Gogh exploited the potential of pen and ink to its full in this drawing to produce an image alive with spontaneous line. A variety of marks and stippled effects together create a

shimmering surface of movement that is heightened by the dynamic composition. The strong diagonal of the quayside and the horizon line that cuts into the top of the drawing create an arena for this scene of constant activity and motion.

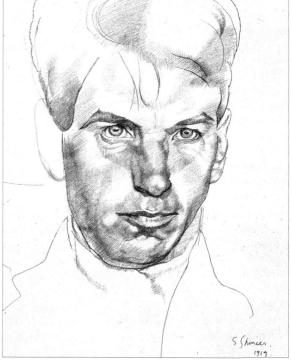

Stanley Spencer, *Self Portrait*, **1919**, *36 x 23 cm (14 x 9 in)*

The strong contours and subtle tones of this pencil study lend it an impressive sculpted quality. The solidity of line and sensitive tones belie the apparent simplicity of the medium.

Pencils & Coloured Pencils

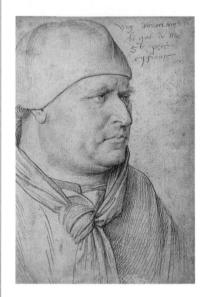

Pencils are the simplest and most immediate of drawing media, enabling you to create a versatile range of strong or sensitive marks. What we call a "lead pencil" today is actually made up of graphite: a mixture of clay and the mineral graphite in the form of a rod that is usually encased in cedarwood. An array of grades exists from very hard to extremely soft, although artists seldom use the hardest varieties because they allow for so little expression when

Silverpoint study

Silverpoint, an original version of the pencil popular in Renaissance times, is a beautiful medium as this 15th century study by Fouquet shows. The basic principle of silverpoint is to leave a metal deposit by dragging a piece of pure silver across some paper previously prepared with Chinese White watercolour paint.

drawing. Coloured pencils are a relatively recent innovation and their waxy nature means that they retain their distinct colours when drawn over each other

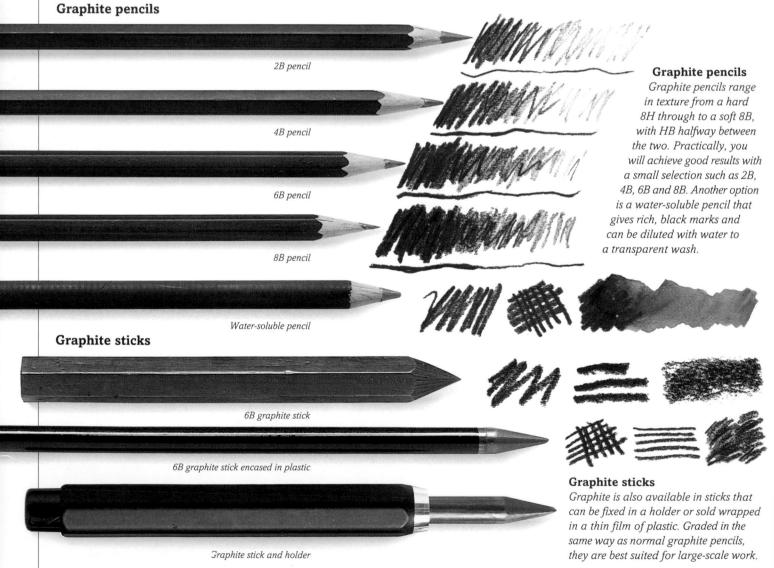

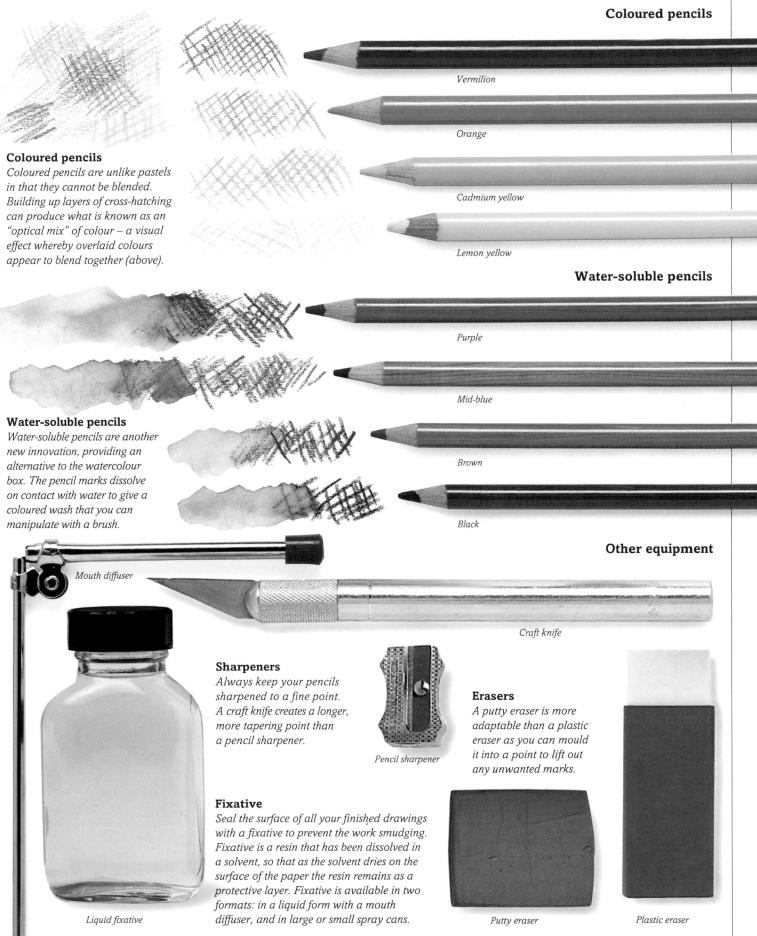

Pens & Inks

PEN AND INK has been for centuries one of the most common drawing mediums. In the past pens were almost always made from quills, although reeds and bamboo were also used. Today there is an abundance of pens to choose from, many of which can be used by artists, although the

quality of ink in most commercially available pens is often poor and will fade over time. Drawing in ink is always a great challenge because the ink is impossible to rub out and so in many senses embodies the spirit of drawing. Every mark made becomes a vital part of the evolution of a drawing and any mistakes can often be used in a constructive and interesting way.

Quill pen

Traditionally made from goose feathers, the quill pen is still hard to beat in terms of flexibility and versatility. Each quill will vary in performance depending on the strength and resistance of the shaft.

Choosing a pen

With so many different pens available, the only way to be sure of what suits your style is to test a random selection. A standard nib holder will take a variety of different width nibs, all of which give a variation of line depending upon the degree of pressure you exert. On the other hand technical drawing pens, which also come in a range of sizes, are hard and inflexible and give a consistent width

zes, are hard and inflexible and give a consistent width of line regardless of pressure. Fountain pens are more convenient and give a good variety of line.

MAKING A NIB

Reeds, bamboo, and goose feathers are all suitable to be made into nibs. Use a craft knife to cut cleanly through one end of a reed.

2 Cut a curved section out of the back and trim the front into a point with two 45° angle cuts. Make a small cut to split the nib.

Reed pen

The common reed (Phragmites) is normally used to make reed pens and, like quill pens, each makes its own distinctive marks.

Pens made from natural fibres need a lengthways split in the tip of the nib to act as a channel to hold the ink.

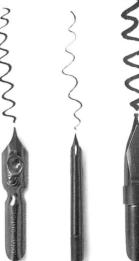

alic nib Mapping nib

Script nih Dr

Dip pens

Steel nibs all respond well to pressure to give a thicker or thinner line. Standard penholders take most nibs, but tubular mapping nibs need a separate holder.

Sketch pen

This pen has a flexible steel nib in a fountain pen format.

Rollerball pen

Rollerball pens act like ballpoint pens to give a steady ink flow.

Fibre-tipped pen

A fibre tip allows the ink to flow smoothly in a thin line.

Technical pen

This pen gives both good control and a consistency of line.

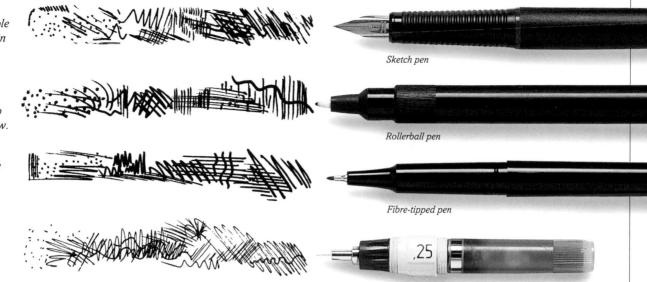

Technical drawing pen

Chinese brush

Chinese ink Use a Chinese brush and ink block (left) for eloquent yet controlled drawings.

Using the right ink

Of the two basic types of ink – non-waterproof and waterproof - most non-waterproof inks will eventually fade if exposed to light. You can easily test for fading by drawing some lines in different inks on a piece of paper and then covering one half and leaving the other exposed to the light for several months.

MAKING INK

You can make a permanent sepia ink with oak galls from oak trees. Crush the galls and boil the powder in water for two or three hours until the liquid is dark enough to strain.

Coloured inks

Chinese ink

Of the many coloured inks you can buy, the more usual colours for drawing are black and a range of browns. In the past ink was usually made with ground lamp black or red ochre and a solution of glue or gum, moulded into dry sticks or blocks to be mixed with water. Prepared in a similar way, Indian ink is a mixture of carbon black and water stabilized by an alkaline solution such as gum arabic or shellac (a resinous substance used for making varnish).

Black ink

Sepia ink

Raw Sienna ink

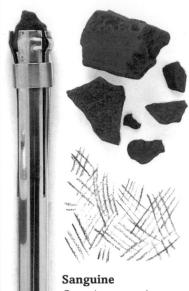

Sanguine – meaning a blood red colour – can be used in its natural form by sharpening a piece of the red chalk to a point and fixing it into a holder. Processed sanguine is made up of iron oxide and chalk and then moulded into bars, sticks, or pencils.

Chalks & Charcoal

White Chalk is one of the oldest of drawing media and has been used in its natural state to heighten artists' drawings for hundreds of years. Red chalk, known as sanguine, is a rust coloured earth which can be located in areas such as central Italy. Nowadays, processed coloured chalks, or crayons, are produced by mixing the limestone rock with pigment, water, and a binding medium. Charcoal, another natural material commonly made of charred willow, is a highly versatile medium that has also been used for hundreds of years. Today the material is often compressed into solid sticks.

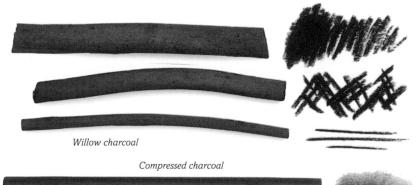

Charcoal

The rich, velvety black quality of charcoal makes it one of the boldest and most evocative mediums. It is sold in different degrees of hardness and thickness. Compressed charcoal has a more intense appearance than willow or vine charcoal sticks.

Conté crayons

A hard version of chalk, these are less prone to breaking and come in a wide range of colours.

Drawing chalks

Similar in texture and appearance to pastels, these leave a finer deposit than crayons. White chalk is only effective on toned paper or over another colour.

Charcoal pencils

Harder than charcoal sticks and graded, these pencils can be sharpened to a fine point for precise work.

Pastel pencils

Pastel pencils are ideal for creating fine lines and for delicate blending.

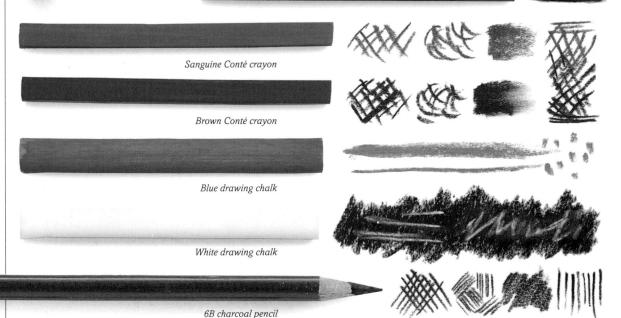

4B charcoal pencil

Drawing with Conté crayon

Conté crayons are a hard version of chalk, mixed with pigment and graphite and bound with gum and a small amount of grease. Their composition makes them harder to rub out than chalk or charcoal so it is difficult to erase any accidental lines. They do, however react in the same way as chalk when mixed with water, with the pigment loosened on the paper so that it acts like a wash. Use a textured paper so that the distinctive qualities of Conté crayon will be heightened.

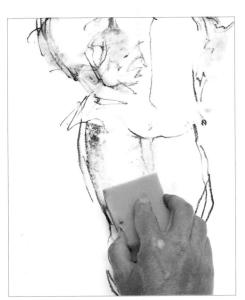

Now use the damp sponge to loosen the pigment in the lines of crayon. The pigment should disperse into a light wash that gives the figure a sense of shape.

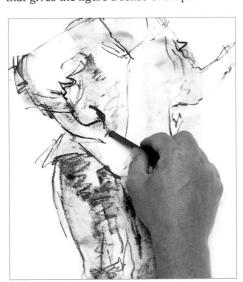

Paper with a household sponge. This damp surface will cause the crayon marks to absorb some of the water and so appear thicker and heavier, giving a sense of solidity to the image of the figure.

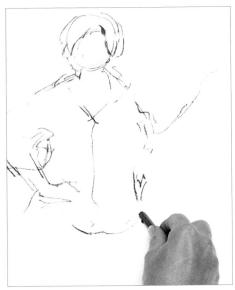

2 Draw the outlines of the standing figure with a brown Conté crayon, sketching lightly to begin with and then reinforcing the lines once you are happy with the proportions. Don't worry about repeating lines if you need to alter a feature.

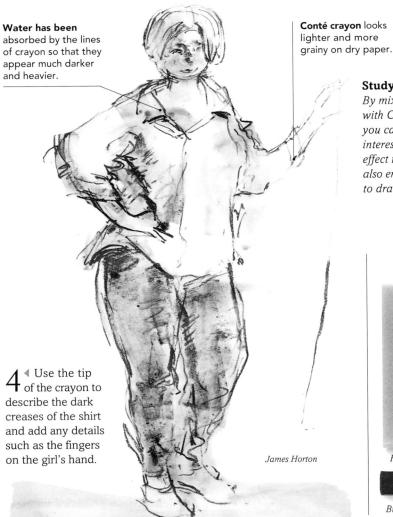

Study of a Girl

By mixing water with Conté crayon you can achieve an interesting drawing effect that should also encourage you to draw lucidly.

Materials

Brown Conté crayon

Pastel Types

The opaque nature of soft pastels and their ability to cover a surface easily means that the medium may often be used in a painterly fashion. However pastels cannot be mixed in the same way that paint can, so they remain within the realms of drawing in as far as the dry sticks of pigment have to be applied individually to the surface of the paper in a series of marks and then overlaid or blended with one another. Pastels are essentially chalk that has been mixed with pigment and a binding medium. They vary in hardness depending on the particular pigments and the proportion of gum to chalk. The harder they are, the better suited they are to linear work.

Pastel boxes

Pastels are sold individually or in boxed sets that keep the colours clean and protect them.

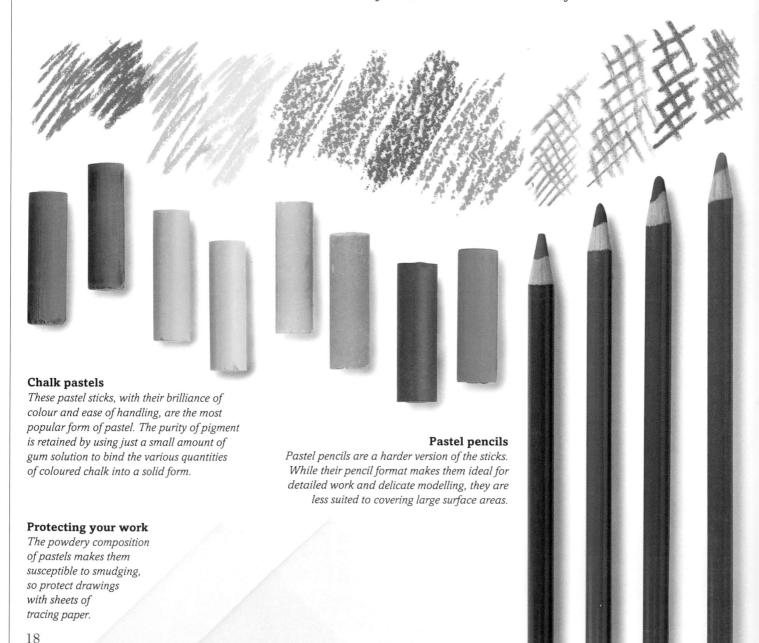

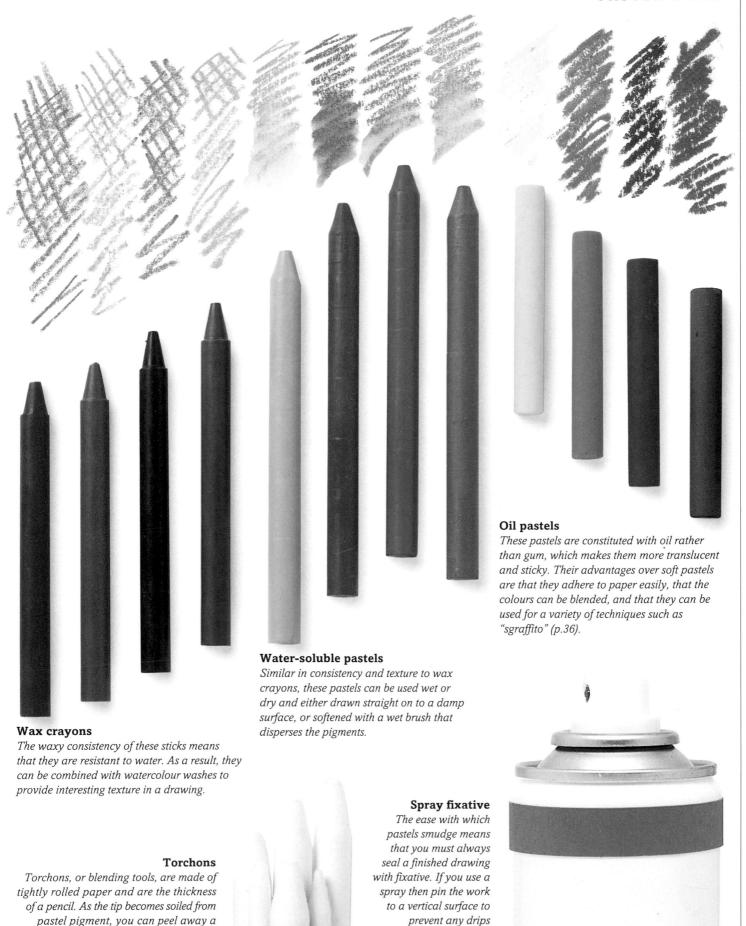

marking the surface.

layer of paper to reveal a clean surface.

WATERCOLOUR

Used initially in the west to "colour" pen and ink drawings and heighten their descriptive qualities, watercolour has been a part of drawing media for hundreds of years. It mixes perfectly with traditional drawing tools such as pencil and ink, furnishing a linear drawing with an expressive rhythm and a pronounced spontaneity. Make sure you use permanent ink with watercolour washes

or the water will dissolve the lines of ink. Watercolour is also useful because it can be blended into a smooth gradation of tones that increase the three-dimensional quality of forms in the most subtle way. Using a sable brush can also enable you to make the most sensuous of watercolour drawings, with its ability to change instantly from a broad, bold brushmark to a fine, tapering line.

Transparency and opacity Transparent watercolour You can blend colours Watercolour is unique for its transparent Size 4 sable brush together or overlay light effects. The characteristic separate washes. luminosity of the medium is caused by natural light penetrating a mix of pigment and water and reflecting sable brush back off the surface of the paper (left). The more colours you mix together, the less light can penetrate and reflect, creating a much darker colour. You can also create stronger, heavier Watercolour box effects by mixing white with a colour, or by using a watercolour paint known as gouache or body colour. The opacity of gouache paint helps to give solidity to an image (below) or to create intense highlights if you are Watercolour boxes drawing on toned paper. Watercolour paint is available in a viscous form in a tube or in a solid block called a pan. Pans are most convenient for drawing as they can easily be used and stored in a metal box. Pans are sold individually so that you can replace particular colours as they run out.

Sable brushes

Soft sable brushes give the best effects with watercolour, retaining their shape far longer than synthetic brushes. A small and a medium-sized or a large brush are all you need for most drawings.

Watercolour sketchbook Opaque watercolour
Build up dark washes

Build up dark washe of colour to create strong shadows.

Working outdoors

Drawing with watercolour is almost synonymous with working outdoors or from life as its fluency and ease of handling enables you to instantly capture even the most fleeting of light effects over a scene. If you do decide to work outside, you can organize a simple travel kit of basic materials that takes up little room and is easy to handle. Use a protective roll to store equipment such as pencils, a dip pen, and sable brushes safely. Take a hard surface such as a wooden drawing board and clips to secure the paper down and to support your hand as you draw.

Canvas roll

Transporting paper
One of the safest ways to
carry paper is to use a
folder or a plastic tube.
You should also include
a can or bottle of fixative
in your kit to prevent
finished drawings from
smudging while they are
stored together.

Collapsible wooden stool

Canvas roll

A protective roll is the easiest way of transporting your drawing materials. The rolls are usually made from canvas with elastic strips sewn in to hold individual items securely. You may also want to take a small wooden stool if you are going to be working outdoors for any length of time.

Drawing board

Although it may be the bulkiest piece of equipment, a drawing board is one of the most important items to include in your kit and is a cheaper and more convenient alternative than a wooden or metal easel. Another option is to use a block of watercolour paper which is sold with each sheet of paper lightly glued to the next to give a solid, flat surface on which to draw.

GALLERY OF DRAWING MEDIA

OFTEN THE SUBJECT MATTER you draw will dictate what type of medium you use. A piece of detailed architecture can be drawn most precisely with a technical pen or a fine nib and charcoal proves itself a superior medium for swiftly capturing the mood of a person. For an elegant, rhythmical drawing of a moving figure, brush and ink offers the widest range of expressive line. Occasionally mixing your media can introduce a whole new facet to your work, but the success of mixing different media together depends upon using each to its best advantage. A pencil sketch can evolve into a more substantial drawing by adding watercolour to strengthen the image, or by adding coloured pencils or chalks to build up the texture in a series of hatched lines. Startling effects can be created by using a heavily textured paper with pastels and crayons in an array of vivid colours.

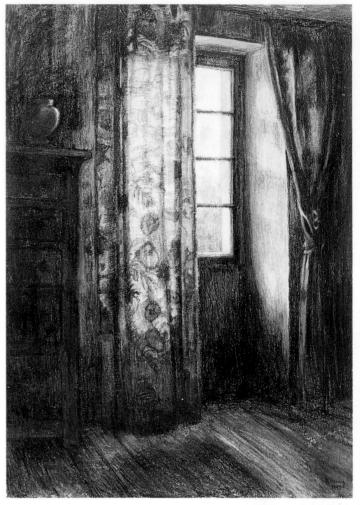

Karen Raney, Les Planes Bedroom Window, 86 x 61 cm (34 x 24 in) The considered way in which these oil pastels have been applied in layers has resulted in a brilliance of colour and a strong tonal pattern that enlivens the work.

A sgraffito technique has been used to scrape away some of the oil pastel colour and produce bright highlights

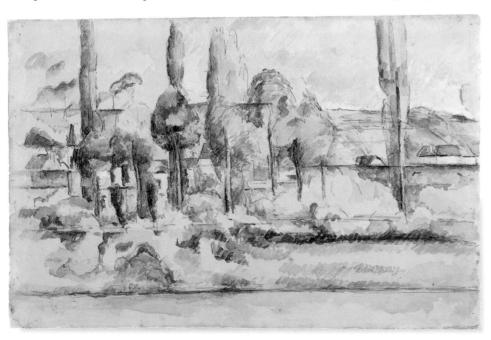

Paul Cézanne, The Castle of Médan, **1879/80,** 31 x 47 cm (12 x 18½ in) Although the majority of Cézanne's watercolour drawings are quite slight, they are full of structure and power. In this study, pencil marks have been reinforced with watercolour to give a strong image that combines a lightness of feeling and a wide sense of space.

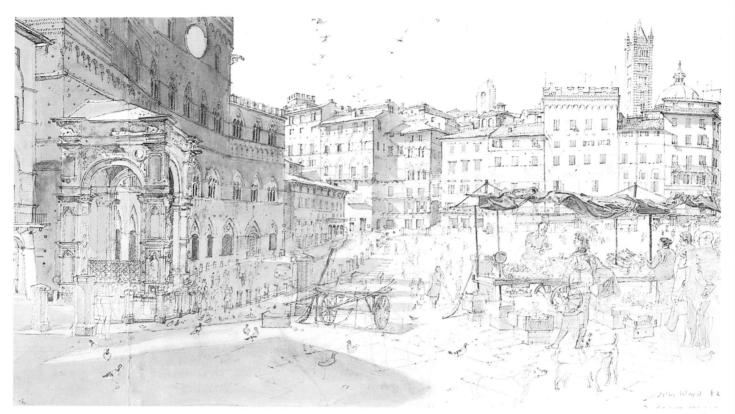

John Ward RA, Siena, 33 x 56 cm (13 x 22 in)
In this picture the artist has caught the dazzlingly bright light that shines on a bustling market square with a clever combination of watercolour and pencil. Rich, deep washes of watercolour have been drawn in shaded areas to heighten the contrast with the stark white paper while clean pencil marks delineate the structure of the ornate Italian buildings precisely.

Jane Stanton, Horace Shadow Boxing,

28 x 23cm (11 x 9 in)

This vigorous drawing in black and white chalks has been built up in a series of rhythmical marks. Interestingly, the white of the paper has been left untouched to depict the bandaged hands, while the highlights on the arm and shoulder have been produced by white chalk. This gives the figure a sense of solidity and heightens the tonal contrasts.

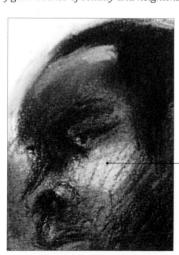

The contrast of intense black shading and lightly drawn linear marks creates a strong sense of movement.

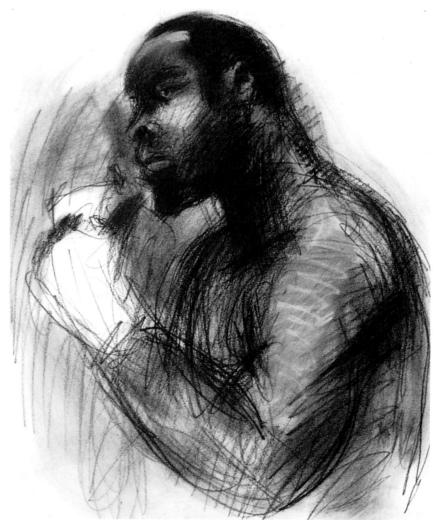

PAPER

RIGINALLY ALL PAPERS were handmade and tended to be of a high quality. Paper was also guite scarce so artists often drew on the reverse side for economy. Toned or coloured paper, prepared by the artist himself with washes of watercolour, was a popular way of creating unusual effects. Today we have an enormous range of papers to choose from,

which can make the choice a difficult one. Both handmade and commercially made papers have varying degrees of absorbency and are sold in different weights. Toned or tinted papers are also worth considering and they are available in a selection of colours. Experiment with textures and weights until you find paper suitable for your techniques.

Toned paper

Toned or coloured paper can add an extra dimension to a work, providing a uniform tone and an underlying unity, as well as influencing the mood of a drawing. Special artists' papers, such as Ingres paper, are best for this type of drawing.

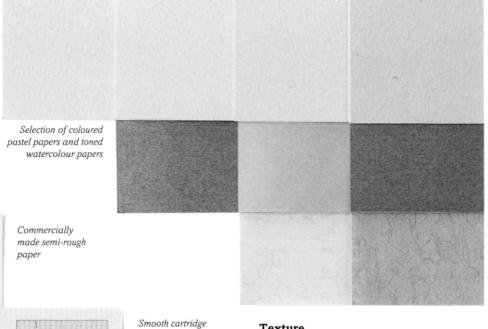

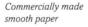

paper

Handmade semirough paper

There are three types of commercially made paper: smooth or hot-pressed (HP); semi-rough or cold-pressed (NOT); and rough. Choose a texture that suits the medium you use; strokes of watercolour emphasize the grain of roughly textured handmade paper, while pen and ink requires a smoother surface to ensure the ink flows smoothly. Try to buy acid-free paper so that it will not darken with age.

Commercially made textured paper

> Roughly textured handmade paper

Making a sketchbook

Sketchbooks can be quite expensive to buy and may contain the wrong sort of paper for your drawing needs. By making your own sketchbooks, you can choose the size, weight and absorbency of paper that best suits your style and media. Use wallpaper samples or wrapping paper to cover the outside of the book.

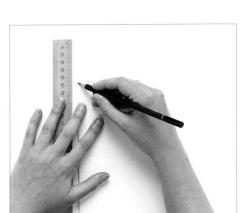

▶ Slip small pieces of tape through each loop and then tighten and secure the thread. You can use any type of fabric tape so long as it is strong and adheres securely to the cardboard covers.

Measure the width of the binding tape first and then place a ruler by the folded edges of the paper and divide its length into five. Mark the tape width at each section with a pencil.

⊃ ▶ Bind the pages with 3 a needle and thread, leaving small loops along the edge of the folds.

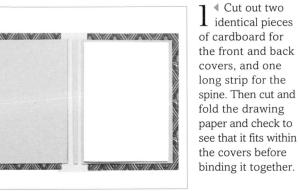

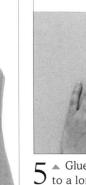

5 $\stackrel{\blacktriangle}{\circ}$ Glue the pieces of cardboard on to a long section of strong fabric, leaving a slight gap either side of the cardboard strip to create a join.

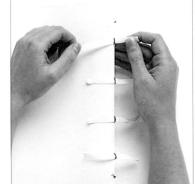

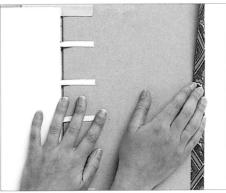

Secure each piece of tape to either side of the cardboard and glue the overlaps of the wallpaper down.

▶ Neaten the inside covers by gluing a clean sheet of paper over the seams and tape.

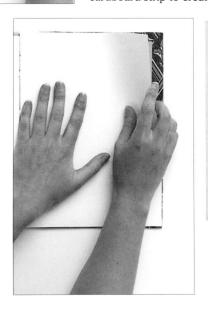

Specialized sketchbooks Try making a variety of sketchbooks in different sizes with a selection of textured or coloured papers.

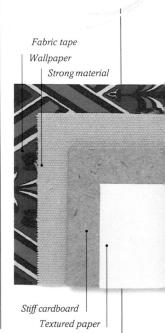

GALLERY OF PAPER

The Texture of paper can easily affect the look of a drawing and it is worth thinking about which type of paper to use for each particular medium. Using a smooth paper for pen work prevents the tip of the nib scratching through the surface, while textured paper readily breaks up any lines or marks and suits media such as chalk and pastel. The absorbency and weight of a paper is important to note before using it with watercolour as it determines the best way to handle the paint and how long a drawing should be worked on. Toned paper can also influence the look and mood of a drawing, serving either to heighten opaque highlights, or existing as a half-tone.

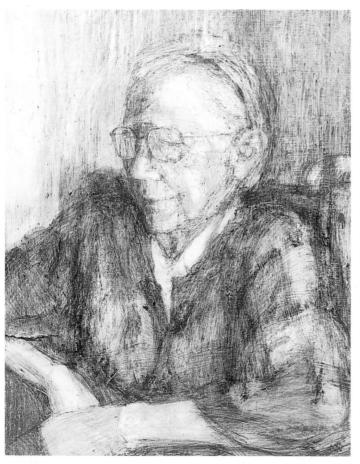

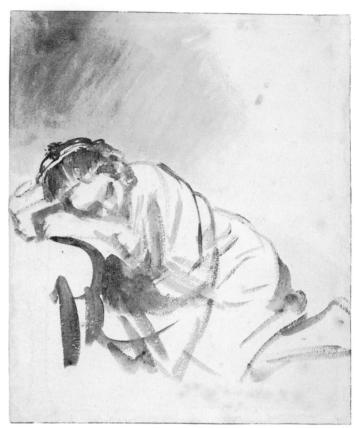

Rembrandt, A Girl Sleeping, c.1655-6, 25 x 20 cm (10 x 9 in)
Rembrandt's brush drawings have an almost unbelievably assured
and spontaneous quality about them. This drawing in brown wash
demonstrates how well the artist utilized his materials, producing a
sensuous drawing of simple line that is brought alive by the textured
paper. The high absorbency of the paper meant that Rembrandt
had to draw swiftly and confidently as the watercolour soaked into
the surface; the paper's rough, grainy texture is emphasized by the
dragged quality of each line as the paint catches on the tooth.

The resilient quality that gesso primer gives this paper has enabled the artist to rework details and scratch out areas to increase the rough texture of the drawing.

Karen Raney, Mrs Robb, 36 x 28 cm (14 x 11 in)

This drawing relies heavily upon a particular technical approach, with the paper primed first with acrylic gesso to give a controlled, significant texture. This resistant surface has meant that the artist can explore her subject in a vigorous style, reworking the figure if necessary with oil pastels in a series of lines and hatchings that are accentuated by the textured paper.

Kay Gallwey, Spanish Dancer, 51 x 76 cm (20 x 30 in)

This work is a fine example of how the quality and colour of paper can influence a drawing; the pale grey tone of this surface heightens the opaque areas of white gouache while still allowing the more transparent strokes of watercolour to show up. Although as absorbent as the paper Rembrandt used, the smoother consistency of this paper allows the artist to draw lyrically, producing lengthy, more generous, brushstrokes. The highlights on the cheek and hair also look most effective against the subtle grey colour of the paper.

The smooth, absorbent quality of the paper points up the stylish strokes of watercolour.

Here the artist has utilized the coloured paper as a half-tone on the hand by building up tones of watercolour around an area of untouched paper.

Percy Horton, *Study of a Farmyard,* **1935,** 30 x 46 cm (12 x 18 in) Drawn on fine Ingres paper, this study in graphite pencil and grey wash easily shows up the smoothness of the surface. The artist has taken advantage of working with such a gentle texture to build up this drawing in an intricate style, incorporating finer details and precise information to give a strong and interesting composition.

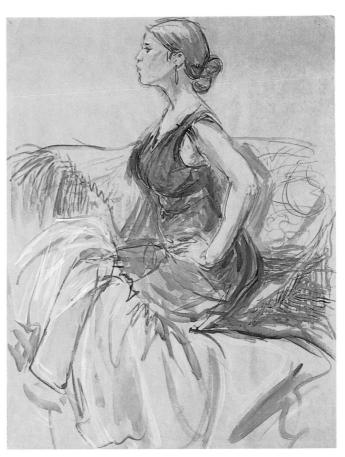

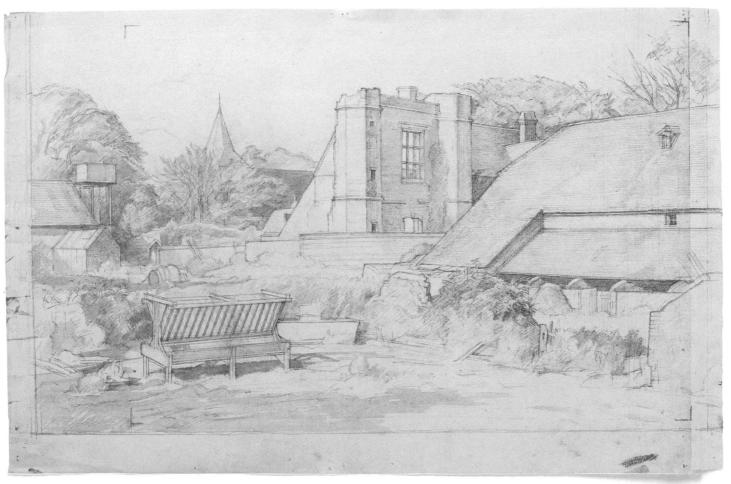

Ways of Working

RAWING IS A SKILL that improves with practice, and the more knowledge you have about your materials, the better your drawing will be. For example, your choice of pencil, pen and ink, or Conté crayon will affect the look of your drawing, and it may be

that one medium suits your purpose better than another. You will need to work with the different materials to familiarize yourself with them, to discover what each is capable of and to see which you feel most comfortable with. Pen and ink is ideal for fine, delicate lines whereas a brush and ink can range from fine lines to broad sweeps

of tone. Once you know the strengths

and limitations of your materials you can choose the appropriate one to your subject matter and to the mood you wish to create.

You will then be able to start a piece of work with a positive idea about how the subject relates to the medium.

Materials to suit your style

Of course each individual will view life differently and two artists faced with the same subject would probably choose different media according to how they perceive

what they see or how they wish to portray it. Rembrandt, for example, used a loaded brush of ink to make rapid notations of fleeting effects and images. You can try to do the same, or make loose strokes with watercolour

washes. Like ink, these will produce an effect very quickly which can then be drawn into with a pencil or pen. You may be more methodical and analytical in your approach, and prefer the control that you can affect with a pencil. Many artists like to map out their drawings with great precision, and for this pencil, ruler, and eraser are the perfect tools.

Choosing the right paper

Do not underestimate the importance of paper. If you work on smooth cartridge paper your pencil will be able to flow uninterrupted over its surface. You will be able to modulate your lines without any unexpected effects. A disadvantage

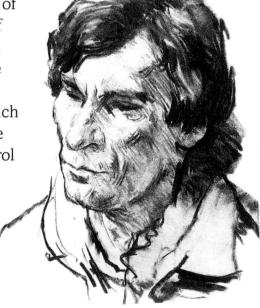

to smooth paper, however, is that large areas of tone may seem somewhat flat. A textured paper is just the reverse: used in conjunction with charcoal or chalks, it gives a lively, broken characteristic to lines or areas of tone. Take note of the weight of the paper too so that if you use watercolours, for example, the paper will be heavy enough not to buckle.

Drawing with watercolour

The point at which a drawing ceases to be a drawing and becomes a painting is both a philosophical issue and a practical one. You can "draw" with colour using coloured pencils, pastels or chalks, or you can add colour to what are essentially linear drawings. You can essentially mix and match – start with pencil and add a watercolour wash, or start with watercolours and strengthen certain details later with pen and ink. By combining such media in this way you can build up a more substantial drawing and create dramatic effects.

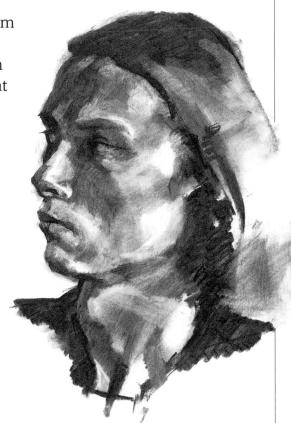

Procedures

Just as there are endless possibilities when mixing media, so too are there quite different procedures. There are no rules about what you can and cannot use, and no set order in which you work with your materials. For instance, you could start a drawing with a pencil, then perhaps add some watercolour. You could then refine the drawing with pen and ink and perhaps

the drawing with pen and ink and perhaps cross-hatch over certain areas with chalks or pastels to create different textures.

Mixing media

Working in this way, you introduce a new medium at various intervals because it strengthens the previous one or creates a new, interesting effect. On the other hand, you could make a decision from the outset to combine a selection of materials and use them in conjunction with each other. It is a question of what effect you wish to achieve and the best way to go about it. As with your drawing skills, learning to make the most of your materials is a matter of time, practice, and pleasure.

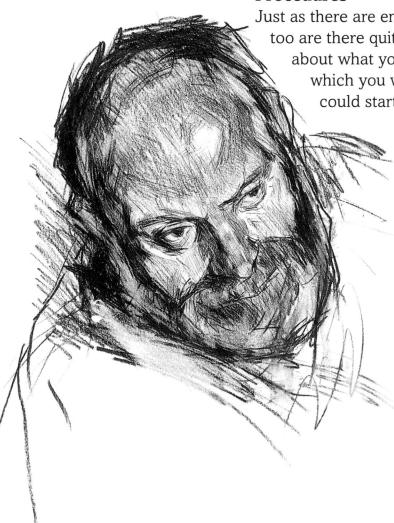

GETTING STARTED

Learning how to see and interpret the world around you; it is vital that you observe images correctly if you want to be able to draw convincingly. Train your eye to look for specific factors as you analyse objects or a scene. You need to be able to distill the information and translate it into an original drawing in your own distinctive style and through your own personal perspective. The best way to begin practising this process is

to take a sketchbook everywhere with you and jot down ideas and sketches for future drawings. Use drawing materials that you are familiar with so that you can concentrate more on how you perceive an image and start to gain confidence in your drawing.

Looking for depth

Every scene consists of a foreground, a middleground, and a background (shown by the black outlines, left). Features in the foreground are large and clearly visible, objects in the middleground appear smaller and less conspicuous, while images in the distance are hazy and undefined. In drawing on a two-dimensional surface, these three divisions create the necessary illusion of depth. Another way to detect these divisions is to look for an intensity of colour: the foreground often consists of strong, powerful hues while the background is full of pale, often bluish tones. This atmospheric condition is known as "aerial perspective".

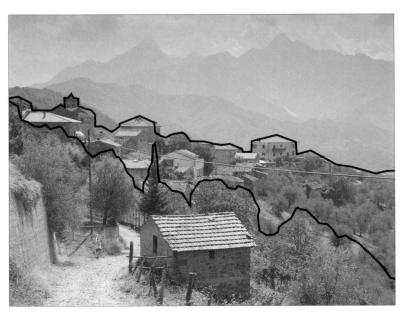

The changing effects of light

The effect of light on an object or a scene is crucial as it can throw whole areas into obscurity, or illuminate one aspect so that it appears to radiate and shimmer. It is worth observing how the sun moves across an object through the course of one day and noting how radically its appearance alters. A variety of warm and cool colours and elongated shapes and shadows transform the look of this building (right) according to the particular time of day. This exercise should help you to judge the best moment to draw a scene or to create a particular mood.

Sunrise

Mid-morning

High viewpoint
The viewpoint you
choose significantly
affects the look of
a drawing. A high
viewpoint allows you
to look down on a
scene which can often
create a sense of
space and harmony.

Normal viewpoint A normal viewpoint — the eye level of an individual standing upright — creates a familiar sense of human perspective. Distant features may be obscured by areas of foreground.

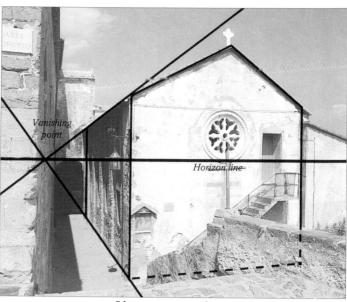

Linear perspective

Linear perspective is a theory based on how we perceive an object or a scene from a particular viewpoint. The building above recedes in space and seems to grow smaller, yet in reality the sides of the building are parallel. If lines are drawn along these sides, they converge at a distant point known as a "vanishing point". A horizontal line across the vanishing point indicates the eye level from which the object is viewed. This theory enables you to represent a three-dimensional image on a flat surface.

Low viewpoint
If you draw from a
low viewpoint, the
objects around you
will appear bolder
and more imposing,
creating a strong
psychological impact.

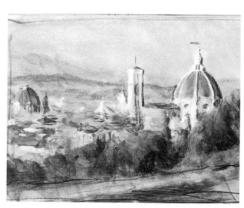

Using a
sketchbook
This watercolour
sketch of Florence,
Italy, includes a high
viewpoint, linear and
aerial perspective,
and describes the
changing effects of
light across the city.

Midday

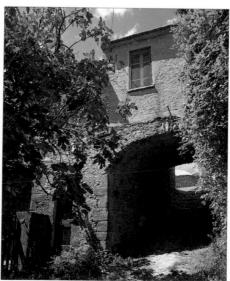

Afternoon

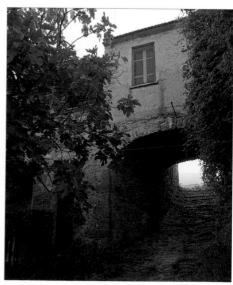

Early evening

THE BASICS OF DRAWING

 $M^{\mbox{\scriptsize UCH OF WHAT WE SEE}}$ around us can be simplified into a series of very basic shapes on paper. The most obvious shapes are cubes and spheres and it is helpful to see objects in these terms when you begin to draw. Regular box shapes with parallel sides are quite easy to practise drawing and a basic understanding of linear perspective and converging lines will enable you to create a better sense of structure and depth. Rounded objects are rather more complex as they should be constructed from a series of ellipses which can initially be quite hard to draw correctly. However, the best way to get to grips with drawing solid objects is to take a collection of household items and practise drawing their different shapes.

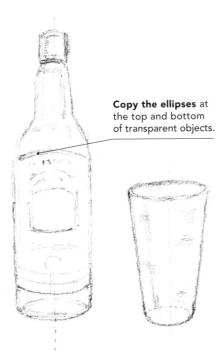

Drawing ellipses

It is worth spending some time practising ellipses so that you can gain confidence drawing round objects. Ellipses are in fact foreshortened circles and change their nature according to your eye level (see below). The principle of foreshortening is that the width of an ellipse remains the same but its apparent height reduces the further it tilts away from you. The easiest way to draw an ellipse is to sketch it roughly and then slice it in half, first vertically, then horizontally. You can then refine it until each quarter is the mirror image of its neighbour. Make sure each corner remains rounded

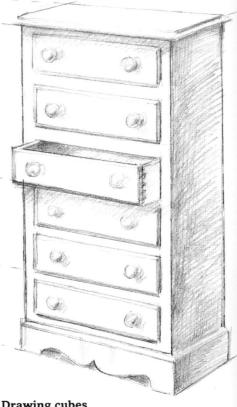

Drawing cubes

This chest of drawers is composed of straight, parallel sides that appear to grow smaller as they recede into space. Converging lines drawn as guides can help you get the right perspective.

and that the middle section doesn't look too flattened. Practise drawing an empty bottle or a glass so you can actually see the foreshortened ellipses through the transparent material.

Changing ellipses

Look at a glass from above, straight on, or below, and the nature of its ellipses will change considerably. If you lean over the glass and view it at an angle, the ellipses will be quite rounded and circular; viewed from the side, they are at an extreme and very foreshortened. Ellipses at the rim and the base of an object are never quite identical: the nearer an ellipse is to your eye level, the thinner it is; the further away, the more circular it is. View the glass from below to see this effect.

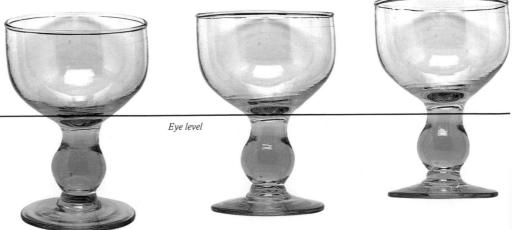

Intersecting ellipses

To recreate the roundness of an object you need to imagine two ellipses, one horizontal, one vertical. The teapot, for example, is made up of a flattened circle for its basic form and then intersected at right angles by a second ellipse. The problem with drawing an object such as this teapot is its opaque nature, so you have to imagine the progression of the second ellipse through the back of the object and judge how foreshortened it actually is. This skill becomes easier the more you practise. Check your eye level and if necessary, draw a faint guideline across the sketch to signify the angle from which you draw so that you create the right shapes.

Multiple ellipses

A complicated object such as this cocktail shaker, whose sides curve in and out, should be constructed of several foreshortened ellipses at different angles and in varying sizes.

Obscured ellipses

Each ellipse has been fully drawn in this sketch of two opaque objects – even though in reality the back of the plate is obscured by the bowl. Once the subject has been accurately drawn, this line can be erased.

Use faint guidelines to establish the centre of the drawing and the angle at which additional features should align.

Still life
Arrange an interesting collection of objects when you feel confident enough to draw several items together. If you want to draw imaginary ellipses through opaque objects, you may need to rub them out when you have finished drawing to give each object a better sense of solidity.

Practise drawing a range of objects so that you learn to describe a variety of ellipses of different depths and widths.

Linear Drawing

 A^{LINE} IS THE MOST basic form of representation in drawing, yet the power and versatility that can be had with the drawn line means that it has a wide range of descriptive possibilities. Linear drawing is essentially a technique that uses line as the main vehicle of expression rather than the

depth of colour. Lines can be drawn with great spontaneity or they can be eloquent, economical, even decorative. Shadows

and highlights can also be suggested with heavy or sensitive lines. A good line drawing will convey explicitly to the viewer what the artist wants to express or describe.

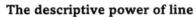

The drawn line can be very adaptable, providing the artist with a vast vocabulary when drawing. Strong, straight lines can be bold and dramatic, sensitive lines may evoke moods and atmosphere or convey lyrical qualities, and curved fluid lines can describe elegant contours. Once you have decided what you want to draw, choose the most suitable materials to either

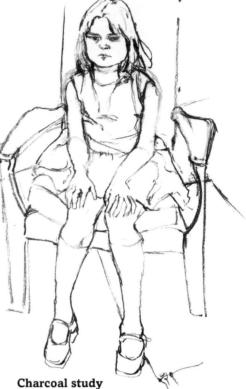

The soft, fluid lines of this charcoal drawing suitably capture the expression and the suppleness of this young child. Lines on the child's hair and dress are economically applied to suggest

texture while other areas are weighted with thick line to give a sense of depth.

emphasize the illusion of solidity and weight or to clarify delicate details and touches with lightly drawn lines. Experiment with different media until you find one that suits your style.

Brush drawing

This canal scene is deftly developed with simple brushmarks. Notice the variation in strength and tone between the bold strokes on the poles and the gentle ripples of water.

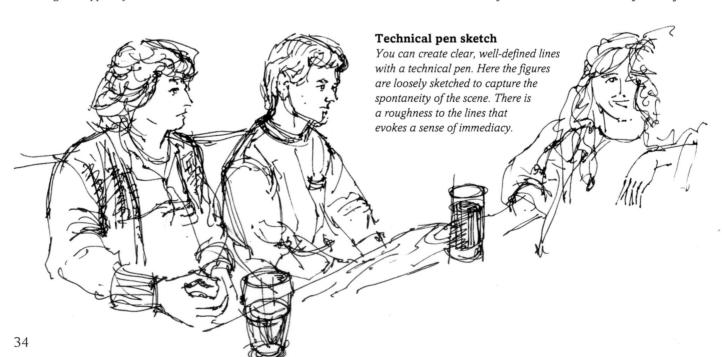

Drawing with pen and ink

Ink applied with a pen is a popular drawing medium. The ink comes in a range of colours just as the steel nibs come in a variety of thicknesses. It is best to use smooth cartridge paper so that the nib does not become stuck in the fibres.

If you are unsure of I drawing directly in pen and ink, start off with a light pencil sketch. This will allow you to make sure your proportions are correct and that you are happy with the composition. It will also train you to be observant.

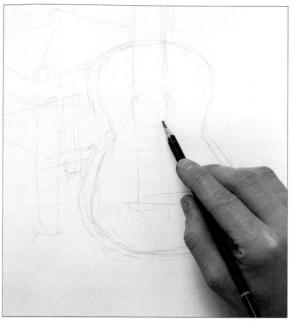

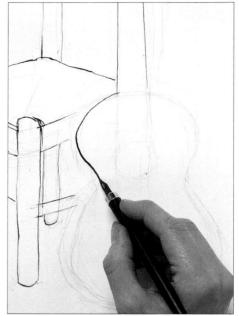

2 Define the snape of the clean straight lines and in contrast ▲ Define the shape of the chair with draw the contours of the guitar with gently curved lines. You may have to apply more pressure to the nib when drawing curved lines to allow the ink to flow easily.

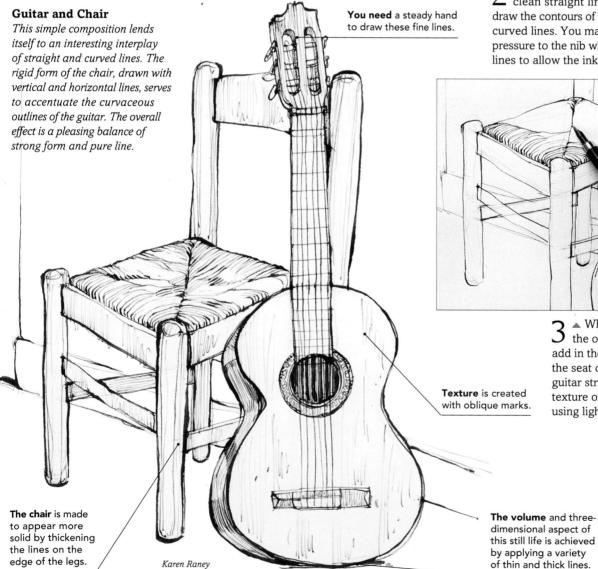

 $3 \ {\tiny \stackrel{\blacktriangle}{\text{--}}} \ \text{When you have drawn}$ the outlines of both objects, Mhen you have drawn add in the finer details, such as the seat of the chair and the guitar strings. Suggest the texture of the rush matting by using light and dark strokes.

> 6B pencil Dip pen

Materials

FORM & MODELLING

JORM IS A TERM that is used to describe the visual appearance and Γ shape of something. In a drawing, form can be represented with line and as a series of tones (a range of values from light to dark) known as modelling. Modelling indicates the solidity and three-dimensional quality of a form, which is often enhanced or accentuated by light hitting the form and creating shadows. There are several different techniques to use for modelling, depending on which type of media you choose. Each medium gives a characteristic set of marks, but materials which cover the paper easily, such as pastels and watercolour, are good for large areas of shading, while coloured pencils, which cannot be blended, are best used for feathering or cross-hatching.

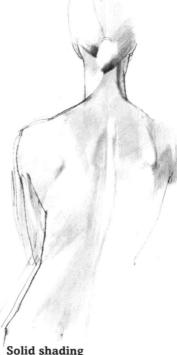

Solid shading

This sketch of a woman's back has been modelled into a threedimensional form by lightly shading solid areas of tone with a pencil. The weighted contour lines also emphasize the volume of the figure. A less linear way of applying tone, this type of shading can be most sensitive and subtle.

Describing form

Although the appearance and solidity of a subject can be suggested by drawing purely with line, a more substantial representation of its form can be achieved with modelling. Look for different textures and any deep tones before you start to draw so that you choose materials and techniques which best depict the smooth curves of a woman's back, for example, or a crumpled piece of material.

Solid shading

Stippling

Cross-hatching

Hatching

Mark-making

There are several ways to shade an image to create a sense of solidity. Hatching, cross-hatching, and feathering are variations of a series of parallel lines drawn close to one another. Stippling is a technique whereby dots rather than lines form an image. Sgraffito, meaning scratched, can be similar to hatching.

Sgraffito

Bracelet shading

Feathering

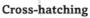

Cross-hatching is a form of hatching, combining two or more sets of parallel lines that cross each other at an angle. They can be used to create a sense of form or, when using two or more colours, to produce secondary colours as the strokes intersect and mix optically.

The cross-hatching on this leg gives it a much stronger sense of form and solidity than the outline of the other lea.

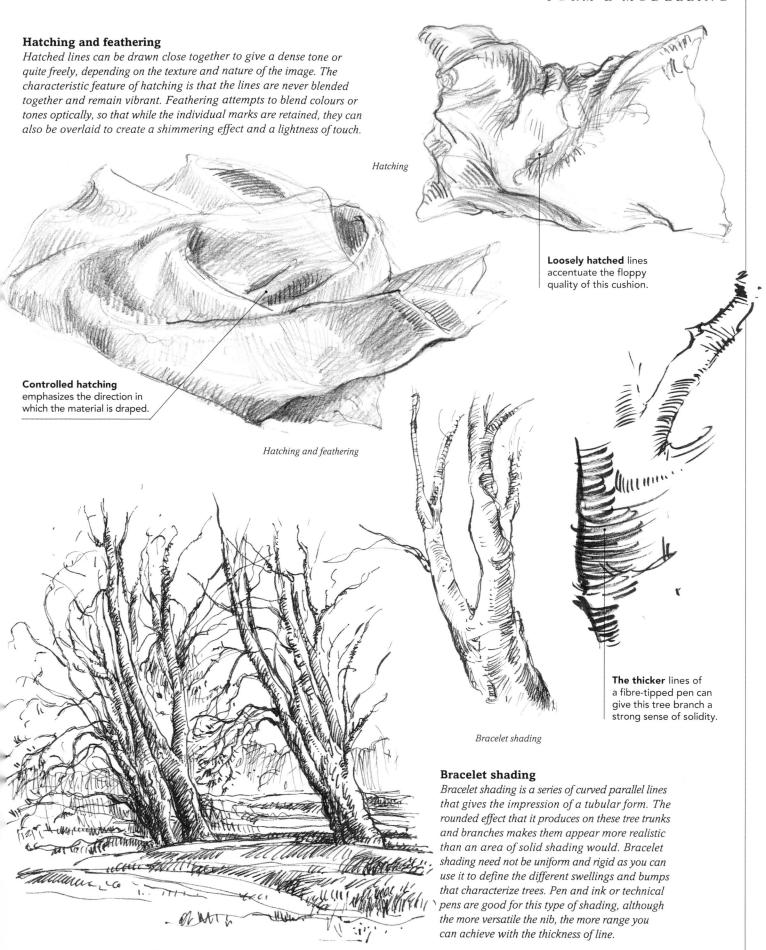

Tonal Drawing

TO UNDERSTAND THE VARYING degrees of $oldsymbol{1}$ darkness and light known as tonal values, it is essential to observe the effects of light and shadows falling on the objects you draw. You can then construct a drawing using areas of tone to describe shapes and to model forms so that they appear three-dimensional. Tonal drawings often tend to be more about mood and atmosphere, where whole areas can be

suffused with light or submerged in deep shadows. A drawing may also be enhanced by using specific areas of contrast to create a tonal pattern throughout the composition. The important thing to remember about tonal drawing is to draw the minimum of lines and keep the emphasis on shapes and forms. Use tones as a painter would use colours to project images and to express a mood.

Lighting effects

To create the appropriate effects of strong light on a still life composition, it is important to set up the lighting at an angle that will maximise the presence of highlights and deep shadows. It is this contrast that will allow you the potential to explore tonal patterns in your arrangement. Use a soft dark pencil for shading the darkest forms and a putty eraser to create highlights by lifting out some of the tonal marks to reveal the brilliance of the white paper. The subtle shading of dark and light tones gives solidity to forms and atmosphere to your drawing.

This monochromatic watercolour sketch of the same still life illustrates how a similar effect of

light and shade can be achieved by using just three tones. Limiting yourself to such a small selection of tones will help you look closely for strong shapes and effective tonal contrasts.

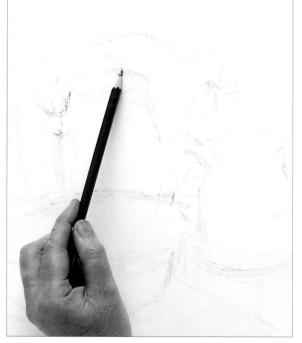

▲ Begin by studying the shapes of the objects and $oldsymbol{1}$ also observe the play of light across their surfaces. With a soft pencil, make a series of loose marks to establish the scale of the arrangement of objects in relation to the size of the paper. Start with the largest object, the plate, so you can use it as a gauge to draw the other objects to scale.

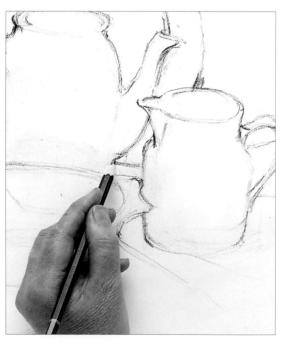

■ Redefine the 2 Redefine loose sketch with stronger lines once you are happy with the composition. At this stage use a lighter pencil to accentuate the contours such as the spout of the coffeepot. These outlines serve as a framework for modelling the objects by shading with light and dark tones.

3 Put in a light grey tone by using gentle sweeping strokes with the side of the pencil. Once this is established you can deepen the tone for shadows and erase it for highlights. Explore the shapes shadows make between the objects: darkening the shadows will push the objects forwards and make them look less flat. Develop the gradated tones on the objects, from the lightest to the darkest, to give them volume.

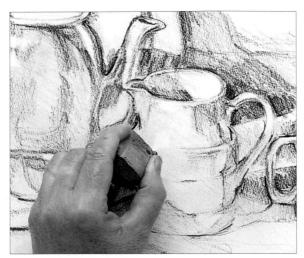

A Now bring out the soft highlights on the jug by lifting out some of the tonal marks with the tip of a putty eraser. This is an effective way of "drawing" the light areas, using the white of the paper as the lightest tint in the tonal scale. These highlights will illuminate every object, as well as imbuing the drawing with a strong sense of light.

Sue Sareen

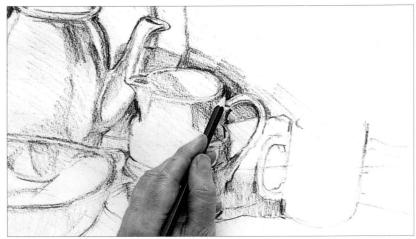

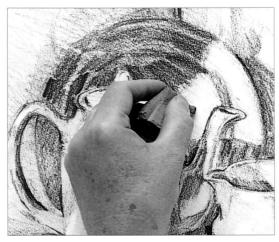

5 At this last stage refine the shadow edges on the plate with the putty eraser so that the darkest tones blend in subtly with the midand light tones to create a pleasing tonal effect. The shadows also enhance the sense of solidity of the plate.

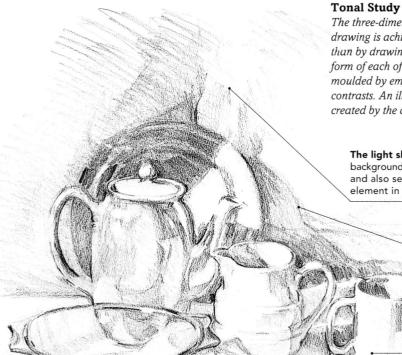

tudy Main ma

The three-dimensional quality of this still life drawing is achieved mainly by shading rather than by drawing with lines. The texture and form of each of the objects are developed and moulded by employing a subtle range of tonal contrasts. An illusion of space and depth is also created by the careful positioning of shadows.

The light shading over the background creates an ambience and also serves as a unifying element in the compostion.

7B penci

Putty eraser

The sequence of shadows cast across the still life and the background forms a pleasing tonal pattern.

The highlights not only indicate the direction of light but also describe the smooth sheen of the ceramic objects.

Light tones and strong highlights capture the transparency of the glass dish and give the impression of reflected light.

Gallery of Form

Sto the visual aspect and shape of an image, but within the realm of drawing it can also incorporate a sculptural quality: during the Renaissance and Baroque periods, the emphasis in art was on creating as solid and as three-dimensional an image as possible. Michelangelo's work has a powerful feeling of shape and structure that goes well beyond a superficial rendering of the human body. This idea of sculpted form is still relevant to drawing today, although it is often interpreted differently. The quality of line may be more expressive and economical and may suggest movement more dramatically.

Michelangelo,

Drawing for a Late Pietà, c.1530s, 40 x 23 cm (15% x 9 in)

One of the greatest artists of the Renaissance, Michelangelo concentrated on the human figure almost exclusively and his anatomical knowledge was impressive. This perfectly proportioned image of Christ is caught by a diffused light that highlights the complexity of muscles and bone structure forming his body. The artist has modelled these features into a dynamic image that still exudes power in spite of the lifeless state of the figure.

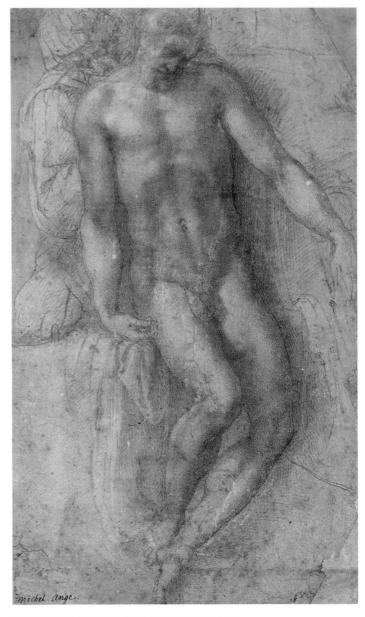

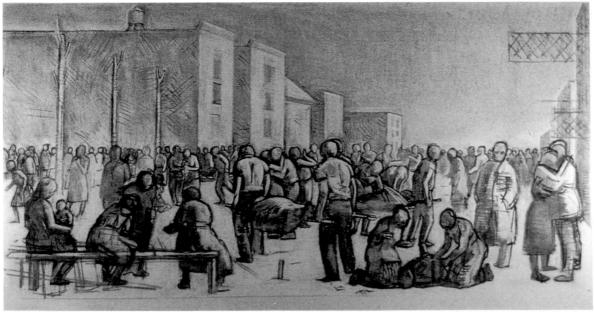

Study for "Bomb", 41 x 71 cm (16 x 28 in) Even at first glance, this drawing has a wonderful sense of structure and strength. The artist has drawn the figures simply, with thick, heavy

Thomas Newbolt,

with thick, heavy outlines so that they seem to create form collectively. He has kept details to a minimum, imbuing the scene with drama despite the anonymity of the figures.

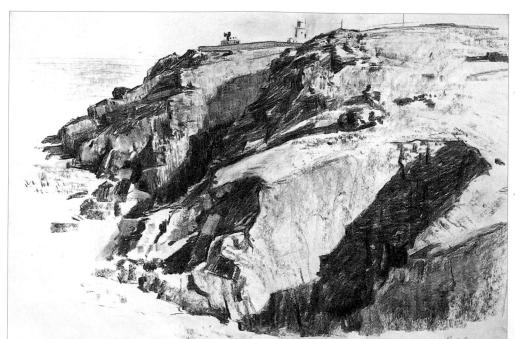

Paul Lewin, Penwith Coast,

43 x 51 cm (17 x 20 in)
Rock formations, with their stark, craggy shapes and dramatic shadows, are a wonderful subject for studying form. The depth and drama of this drawing relies upon a bright light that picks out the eroding coastline as a series of unusual and abstract images. Deep shadows help to build up a strong tonal pattern that combines with the highlights to give a three-dimensional form with a striking presence.

Donald Hamilton Fraser RA,

Dancer Rehearsing Juliet, 46 x 51 cm (18 x 20 in) Watching dancers or acrobats is a good way to study the human form as it moves. Here the artist has made a sensitive yet elegant study of a dancer caught mid-way through a sequence. The essence of the power in this drawing is in the economy of line that describes the form of the body so succinctly. Areas such as the hands and legs assume a sense of solidity despite the simplicty of line.

Thick, simple lines of chalk across the upper body suggest shadows and create a realistic sense of shape and depth.

A repeated line along the arm echoes the constant movement of the dancer.

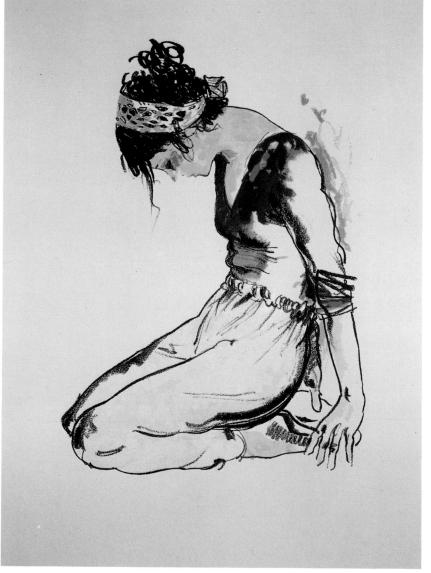

LAYOUT & CONSTRUCTION

THE LAYOUT, OR COMPOSITION, of a drawing should provide a balanced order of shapes, colours, and forms. Use a viewfinder to choose the most appropriate scene and then draw the layout by measuring every feature carefully.

Measuring is an essential element in the construction of a drawing as it provides a scale by which to judge the relationship and proportions of different masses. Objects can be visually measured with the end of a pencil.

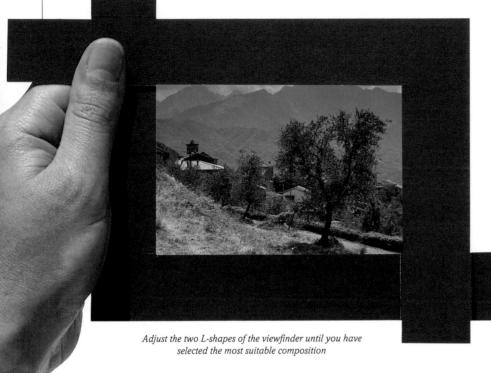

It is often difficult to select just a few elements of a landscape for a drawing, so use a viewfinder to crop the scene in front of you.

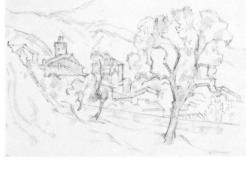

Using a viewfinder

A viewfinder made from card (left) can help you select the part of a scene you wish to draw and it can be adjusted to different proportions. The amount you see through the frame varies according to how close you hold it to your eye and how you adjust the two L-shapes. Make a quick pencil sketch of this cropped image if you want to make sure the composition works well.

Measuring

If you work on a large composition, or from sketches and photographs, you may prefer to establish a scale to measure the different components of a scene. However, if you draw directly from life, try using a "sight size" technique. This involves measuring the size of an image exactly as you see it with the end of a pencil or a ruler. Transfer the measurement on to paper so that the image is an identical size.

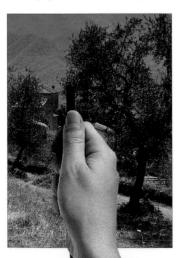

Drawing a series of buildings from life

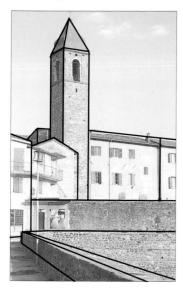

Deconstructing an image

A scene such as this group of buildings may at first appear quite complex and rather daunting, but if you can reduce it to a series of simple shapes and three-dimensional blocks in your mind, you will gain a better sense of perspective and structure as you begin to draw.

Drawing from life can be both stimulating and problematic, so plan your composition carefully and measure constantly until your eye becomes practised at judging size and scale.

1 Draw the outlines of these buildings as a series of simple lines on a large piece of semirough paper with a soft pencil.

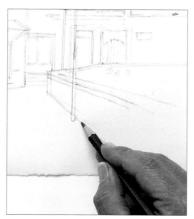

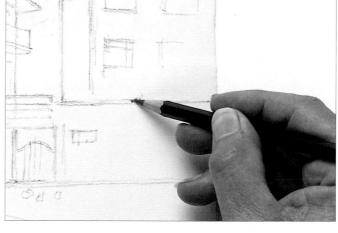

2 The wall in the foreground provides a strong sense of perspective, so draw it as a set of converging lines.

3 Add in the fine details, checking that doors and windows are in proportion to the size of the buildings.

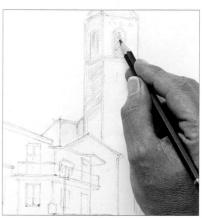

The Bell Tower

This simple pencil drawing has been constructed as a series of simple blocks and shapes that provide the basic substance of the drawing. The main features were all measured before they were drawn on to the paper and developed into more detailed structures once the proportions and balance of the picture had been established.

The three-dimensional appearance of these buildings creates a strong sense of depth.

Individual features have been measured carefully so that they have the right proportions.

This wall has been constructed with lines that tend towards one another to give a powerful sense of perspective.

James Horton

Materials

4B pencil

PLUMB LINE

A plumb line – a small weight on the end of a piece of string that gives a true vertical line – is vital if you need to check how straight and balanced a building actually is.

Buildings & Architecture

The Great advantage of drawing buildings is that they are permanent and stationary, so you can take your time to study the subject. Perspective is one of the most important elements to grasp if you want to draw a convincing architectural study; how an object with regular sides appears to diminish towards

a vanishing point and so create a feeling of recession. It is also vital to get proportions right so that the space occupied by windows and doors is in relation to the overall size of the building and the scale of any ornate or interesting features is exact. Modern buildings are usually quite regular in appearance, while older buildings such as cathedrals are likely to be more ornate and will adhere to classical rules of proportion. Look out for the changing effects of light on architecture as it can create interesting patterns of highlights and shadows, and try to describe a variety of textural surfaces to enliven your drawing.

Once you have chosen an interesting building to draw, pick a quiet spot where you can easily view the whole structure – preferably at an angle so that you can draw more than one side of the building and give a greater sense of solidity. The eye level from which you view it is also worth thinking about, especially if you want to emphasize the height of an imposing building.

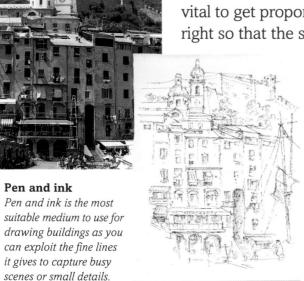

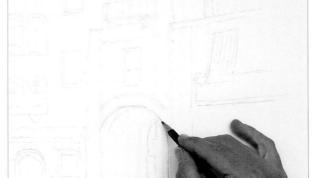

 \mathbf{l} Draw the basic structure of this building as a series of simple geometric shapes with a pencil on smooth Ingres paper; handmade paper would be too rough and uneven when you start using pen and ink. The building is slightly curved, so look for the way the light accentuates these different angles.

Simplifying details
You can easily simplify the
buildings you draw if there are
too many extraneous details,
or omit unsightly objects such
as parked cars. Such details
can look too prominent and
may compete unnecessarily
with the architectural design.

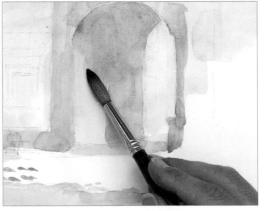

Mix up a pale brown wash of watercolour and apply it liberally over the drawing with a large sable brush to suggest the general tones of the building. Mix a deeper wash for areas with the darkest shadows such as the overhanging trees to the left and the inside of the archway.

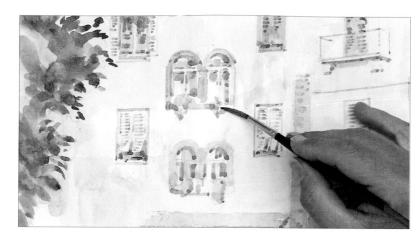

For the finest details, use a brown sepia ink and a dip pen with a steel nib. Draw in the ornate wrought ironwork of the balcony carefully, trying not to put too much pressure on the nib - any heavy lines will detract from the delicate quality of the pen work.

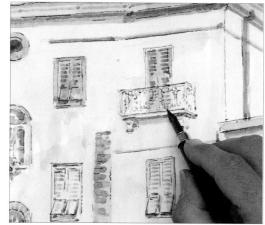

■ When the wash of colour has dried, use a small sable brush to depict the textures and details of the building with a darker brown, describing the brickwork and the wooden slats of the window shutters with gentle dabs of colour. Sable brushes, with their finely tapered points and ability to retain paint, allow you to draw far more precisely than other types of brush.

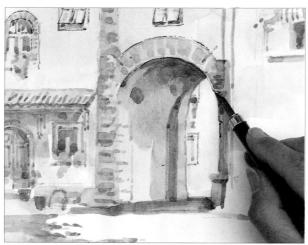

Finally, emphasize any details that need to be made more prominent with the dip pen and sepia ink. The colour of this ink serves to enhance rather than detract from the brown watercolour wash. Remember to select only those details that interest you or heighten the characteristic design of the building.

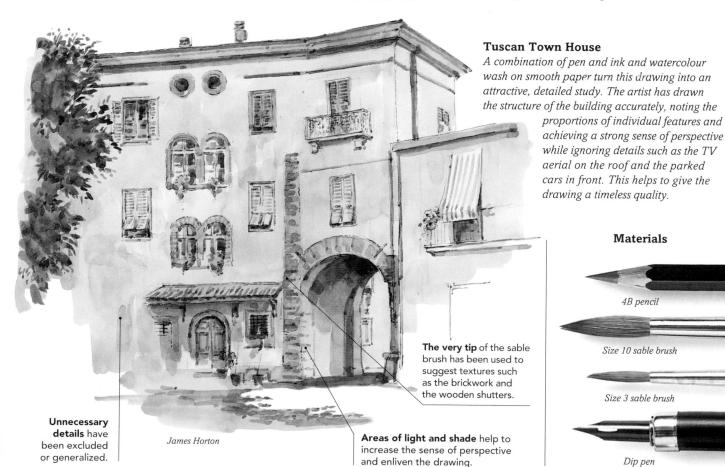

Materials

Interiors & Exteriors

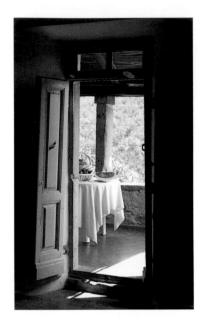

The most modest interior or garden can provide plenty of inspiration for an artist, particularly if the scene is familiar. The advantage of working in such immediate surroundings is that you can look for unusual shapes and interesting spatial relationships in simple objects such as chairs or tables. Combining an interior scene with an exterior view beyond can add an extra dimension to a work and prove a great challenge, particularly in terms of describing the contrasting quality of light inside and out. Select the amount of information you draw in each area to give a balanced composition.

The changing quality of light

The natural light that permeates interiors has a very different quality to that of light outdoors. A variety of suffused rays and deeper tones give interiors a mellow, quiet atmosphere that provides an effective visual contrast with the strong, even light of outside.

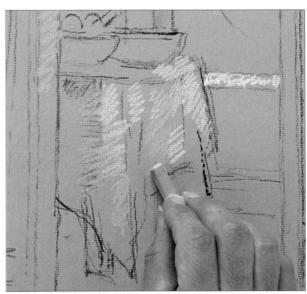

1 Look for the rich, vivid colours of the view outside and the cool, muted tones of the interior. Sketch the scene in charcoal on mid-toned brown Ingres paper and then apply pale pastel tones to the tablecloth.

2 Contrast the pale pastels with deep purple and black on the door frame, using a hatching technique. The fine lines of colour should appear to blend together optically.

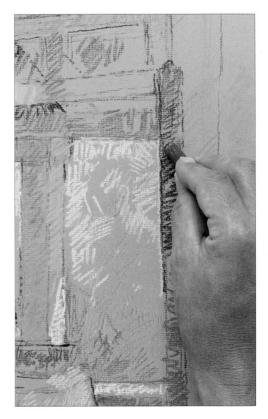

Once you have decided on the basic areas of warm and cool colour, begin to overlay the pale colours of the sunlit balcony with richer tones. Use a feathering technique to apply a strong

pink over the pale mauve of the balcony floor. This combination of colours should produce a lively, sparkling effect. If you are at all unsure about using a particular pastel colour on the toned paper, try it out first on a corner to see how it looks.

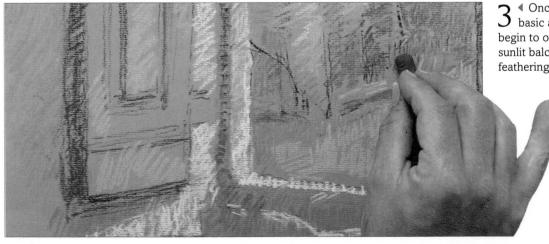

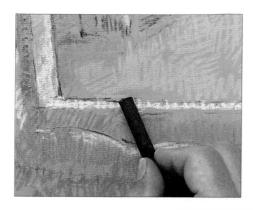

4 Emphasize the contrast between the balcony and the interior by drawing dark lines of charcoal in the deepest shadows of the doorway.

5 The interior is full of hazy, reflected light – light that bounces off objects in full sunlight. The angled ceiling above the doorway gives off this soft, shimmering light, so use a pale pink tone to draw it.

6 Finally, rework the fruit on the table with the brightest pastel colours. Then balance the strong hues of the still life by accentuating the details of the doorway with charcoal. Try to keep the background undefined and rather pale to increase the sense of distance beyond the balcony.

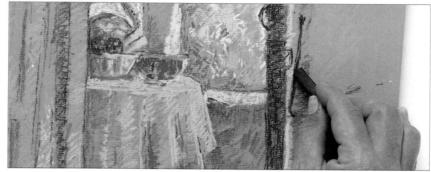

Still Life on a Balcony

This drawing is built up of colour contrasts – with bright, vibrant pastels describing the scene outdoors and darker, more subdued hues evoking the shady interior. This pattern of highlights and shadows sets up a series of strong tonal values through the drawing, which also gives a good sense of aerial perspective. The doorway effectively frames the whole composition and leads the eye up easily to the active focal point of the fruit on the balcony.

Pastel marks have been left unblended so that the drawing has a sharp clarity.

Bright pastel colours, either pale or strong in tone, have been used for areas in sunlight.

The contrast between the light balcony and the dark interior increases the sense of atmosphere and the aerial perspective, or depth, in the drawing.

James Horton

Pastel selection for interior

Pastel selection for exterior

KEEPING YOUR WORK CLEAN

Pastels and chalks generate a fine powder as you work with them, so use a sheet of paper to lean your hand on as you draw. This technique is also useful with lead pencils.

GALLERY OF COMPOSITION

DRAWING CAN BE ANYTHING from a quick Adoodle in a sketchbook to a highly finished piece of work, yet composition is an important part of any drawing. Composition relies upon a variety of factors, such as the arrangement of shapes and forms and the degree of tone and colour. The more complex a drawing becomes, the more you need to consider how individual elements will interrelate to form a cohesive, interesting whole. An unusual viewpoint or angled composition can also produce an engaging work. You may find after starting a drawing that you want to explore areas beyond the existing confines of the paper, so add an extra sheet to develop the work into a larger composition.

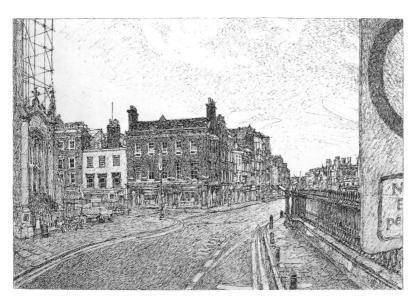

Jon Harris, King's Parade, 56 x 76 cm (22 x 30 in)
This work has an extraordinary abundance of lines and marks which the artist has built up using a technical pen while actually sitting in the street. The powerful perspective that characterizes this composition is exaggerated by the road that engulfs the foreground and then converges rapidly to a vanishing point in the distance. The large, dissected road sign dominating the right of the picture increases the immediacy of the composition and gives it a less structured feel. A network of cross-hatched marks helps to give the picture tone and texture.

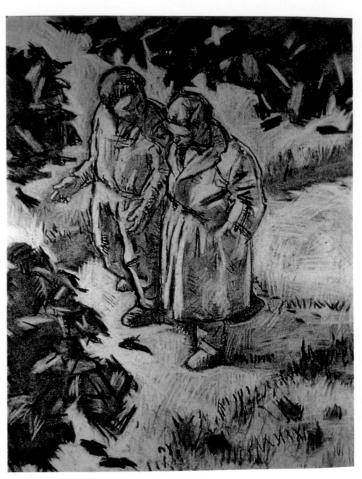

Thomas Newbolt, Study for the Bandstand III, 61 x 46 cm (24 x 18 in) In this charcoal drawing the artist has used an ingenious vantage point from a tree so that he almost spies on the figures walking below him. As a composition, the drawing is simple but dynamic, with the figures held carefully in place by the diagonal path and the foliage of the tree that frames them.

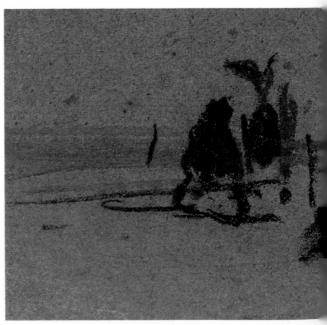

Jane Stanton.

Behind the Scoreboard, 25 x 36 cm (10 x 14 in) This drawing is one of a series the artist made while sitting behind a cricket scoreboard. Although our attention is immediately drawn to the two seated figures, the artist is also fascinated by the shapes within the room – the intersecting lines of the walls, the repeated image of the doors, and the overhanging cupboards. By placing the figures at an angle, she intensifies our interest and heightens the sense of drama in the scene.

Anne-Marie Butlin, Two Pears, 25×30 cm (10×12 in) This carefully thought out composition transforms a deceptively simple still life into a fascinating study. Viewed from a close angle, the edge of the table that cuts across the picture divides the composition in two so that our attention on the fruit is even more intense. The uneasy positioning of the pears also implies that the artist has sought to generate a certain degree of tension in this picture.

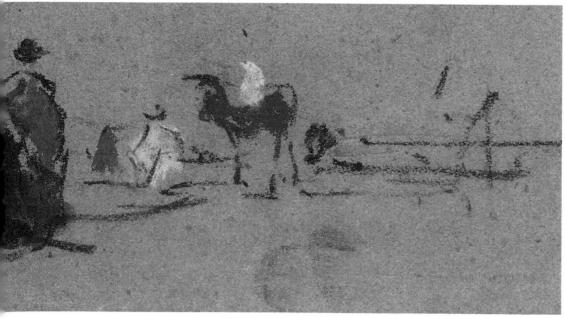

Boudin, Beach Scene, Late 19th century,

29 x 72 cm (11½ x 28½ in)
This delightful pastel captures the fun of people relaxing on a beach. Boudin has deliberately chosen a long, thin format to reinforce the sensation of gazing out at an endless stretch of coastline. The impressionistic suggestion of figures and shapes in coloured pastels gives a spacious, indistinct feel to the drawing so that the scene appears to exist beyond the confines of the toned paper.

Drawing Natural Forms

RAWING NATURAL FORMS tends to be a genre of its own as it requires a more observant and investigative approach: to record precisely and in detail the appearance and workings of an animal or a plant. You need to work methodically to capture the particular characteristics

> of your subject, rather than applying your own personal artistic interpretation. Select a medium that is sympathetic to the quality of the object – a bold medium for vigorous drawing and the clean lines of pen and ink for more exacting work.

Crustaceans

Crustaceans are fascinating to look at and the "mechanics" of a creature such as this lobster are intriguing. The longer you examine how the different joints are connected and the effects of the hard shell reflecting

existing pencil marks.

the light, the more realistic your drawing will be. Use a pencil first to establish the essential shape and features of the lobster before you move on to the permanent medium of pen and ink.

▶ Arrange the lobster and sea shells in a corner where they can be left to enable you to take your time to study and draw them. Sketch in the basic shape of the lobster with light, gestural strokes on smooth watercolour paper, using a pencil with a long, sharpened point.

Beachcombing is one of the best ways of finding interesting material to draw.

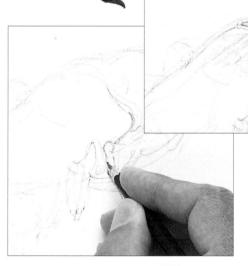

3 with a medium-sized sable brush and a wash of pale yellow, begin to build up the form of the lobster. Apply the watercolour sparingly if you are worried about over-emphasizing any aspect of the work at this stage.

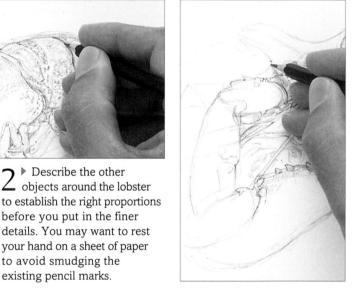

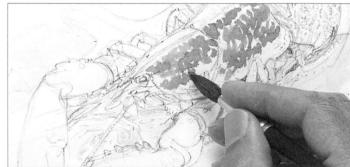

▲ When the first wash of watercolour has dried, apply a scarlet-brown wash to the main body of the lobster in a series of dabs to echo the appearance of its mottled shell. The springy hairs of the sable brush should give you good control as you paint.

5 Lightly shade areas of the background with a thin wash of dark brown to give a sense of depth to the drawing and push the form of the lobster forward.

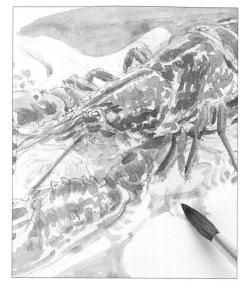

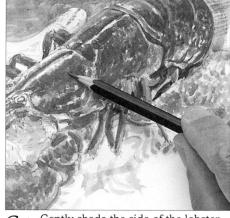

6 $^{\bullet}$ Gently shade the side of the lobster shell with the pencil to build up a series of dark tones. This should help to give the image a three-dimensional appearance.

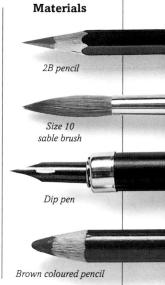

We a dip pen and sepia ink to redefine the shape and details of the lobster. Accentuate any areas in shadow with thick, dark lines, and highlights with thin, faint lines of ink. Hatched marks drawn in the darkest shadows will also push the image forward.

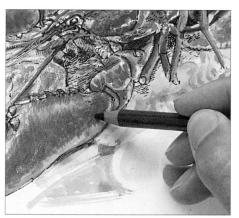

O leepen the tones of the shell and claws with a dark brown coloured pencil. The pencil marks will also add texture to the drawing and help to break up any areas of paint that look a little flat.

51

Norfolk Lobster

The artist has taken his time to study this lobster, and the result is a beautiful and meticulous drawing with a wealth of detail. The layers of colour and texture have been applied carefully to give the lobster a powerful sense of form, while the clean, crisp lines of ink define particular features that turn this drawing into a fascinating reference work.

Layers of watercolour have been built up into a series of subtle tones that mould the form of the lobster effectively.

A coloured pencil breaks up the flat areas of watercolour and provides texture.

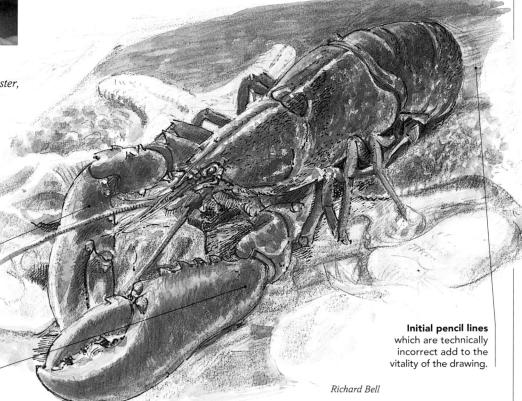

<u>Landscapes</u>

DRAWING LANDSCAPES is a relatively recent development in art and it was not until the eighteenth century that the changing effects of light and weather in a landscape became such a popular subject matter. It is always essential to be aware of the passage of the sun across a scene as the definition of individual features and the length of shadows can change dramatically. Perhaps the greatest problem when you are drawing a landscape is choosing which features to include and which to leave out. A viewfinder is the best way of

selecting one view from a broad panorama. Watercolour is one of the most suitable mediums to use for drawing landscapes as it enables you to capture the transient effects of the weather quickly.

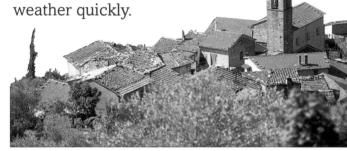

I be use a viewfinder to select an appealing composition. With a pencil, measure the proportions of the hill village and draw it in a series of blocks and triangles on rough watercolour paper. The slightly off-centre positioning of the village creates an unusual composition and the vegetation surrounding it can be sketched in gradually to balance out the drawing.

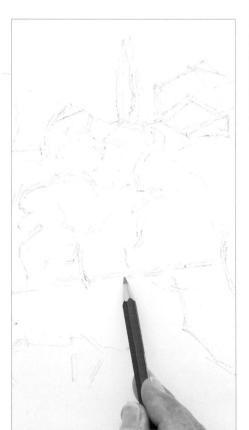

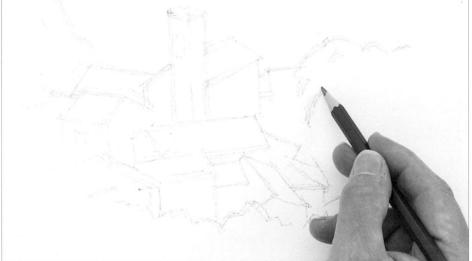

2 Look for any features in the foreground and middleground, such as trees or a sloping hill, that give a sense of perspective; a diagonal line on the left helps to lead the eye up to the village. Keep the landscape to the same scale as the village by measuring the different features carefully.

When you are happy with the scale of the composition, add some watercolour with a small sable brush to capture the effect of sunlight on the buildings. Use a wash of warm red for rooftops and cool purples for shadows.

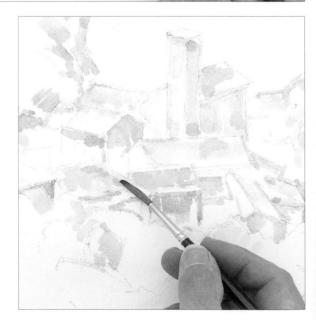

A Describe the trunks and branches of the trees in the foreground with the sable brush and a pale brown wash. Apply the wash lightly to retain the clarity of line and lift out any mistakes you may make with a piece of kitchen roll.

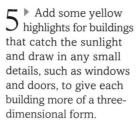

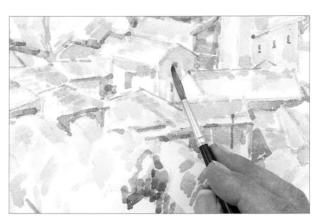

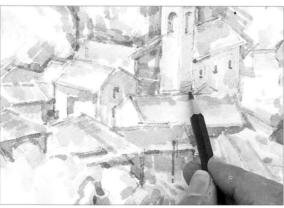

6 Use the pencil to suggest any shadows that are cast by the bell tower. Angle the pencil slightly so that you can gently shade the darkest areas. If the surrounding landscape still appears rather sparse, add more light, gestural strokes of watercolour to strengthen the composition of the drawing.

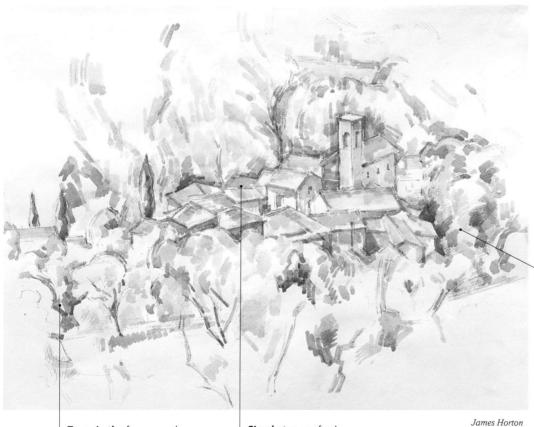

Trees in the foreground are used as identifiable landmarks and give a sense of perspective to the drawing.

Simple tones of colour on the buildings evoke the sensation of bright sunshine hitting the village at an angle.

Mediterranean Hillside

The paper used for this drawing was quite absorbent, so that every mark made with the sable brush was linear and decisive, reinforcing the simplicity of the initial pencil drawing. The repeated watercolour marks also help to give the sensation of a large expanse of hillside stretching out around the small village.

The surrounding vegetation is merely suggested, rather than described in detail.

Materials

Size 4 sable brush

Gallery of Natural Forms & Landscapes

PRAWING NATURAL FORMS has often brought artist and scientist together. Many of Leonardo's drawings, for example, work equally well as drawings from life and as detailed scientific studies. Until the advent of photography in the mid-nineteenth century, drawing was used to illustrate all manner of different subjects - resulting in a combination of images that were beautiful to look at and filled with relevant information. Drawing is all about the way we perceive the world around us, which is perhaps why artists turn so readily to landscapes and natural objects as a source of inspiration. Some interesting landscapes contain not only natural features; man-made buildings in a landscape can often strike a balance with the natural forms around them so that they seem to be subsumed into the environment.

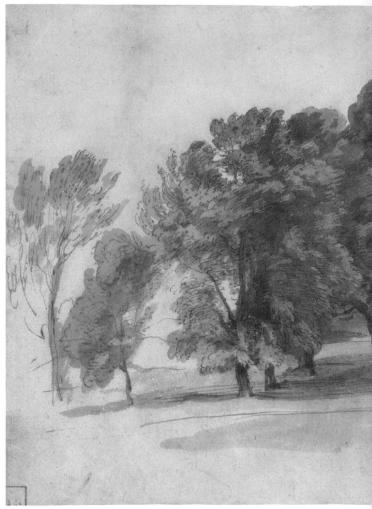

Van Dyck, Study of Trees, Late 1630s, $20 \times 24 \text{ cm}$ ($8 \times 9\%$ in) The feathery texture of the trees in this lyrical pen and ink drawing point to Van Dyck's concern for a stylistic interpretation of his subject rather than identifying particular trees.

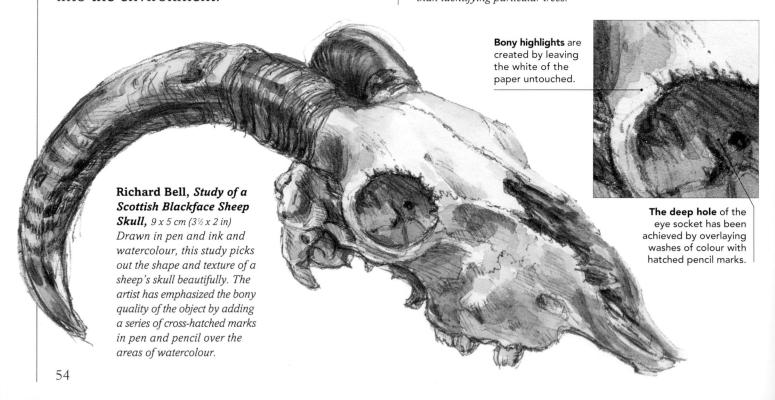

GALLERY OF NATURAL FORMS & LANDSCAPES

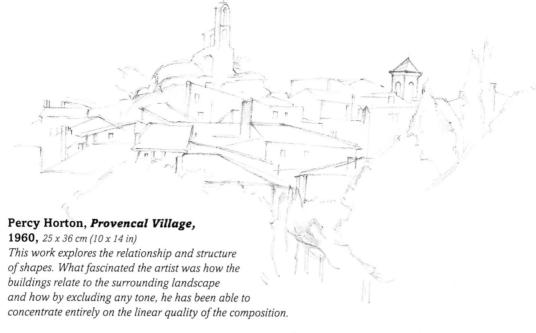

Paul Lewin, Seascape (After Courbet), 64 x 71 cm (25 x 28 in) In this drawing the artist, rather like Van Dyck, has concentrated on a personal interpretation of a natural scene. He has applied pastel and charcoal vigorously to develop a dramatic sense of mood and atmosphere. Although the picture has a low horizon point, the sky is brought alive with strong colour and texture to form a surface full of movement. This work illustrates how a landscape can be used as a springboard for a personal vision.

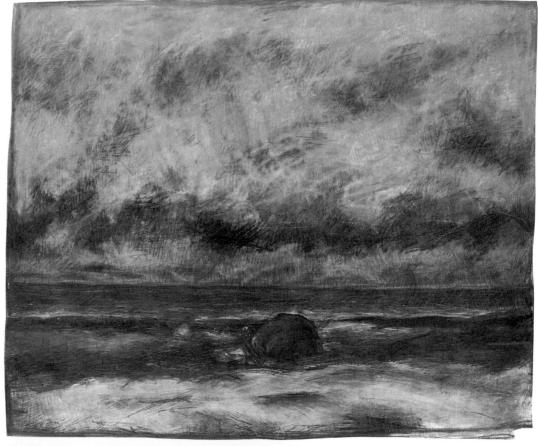

The lack of fine detail gives this seascape an expressionistic feel which is heightened by the limited use of colour.

The dark, moody atmosphere of this drawing has been heightened by a series of deep tones and heavy cross-hatching.

FIGURES & DRAPERY

Cit is important to understand how material behaves as it falls in folds around a figure. The simplest way to draw a clothed figure is to work out the proportions of the body first and draw it as a series of simple forms, ignoring the flowing shapes made by the drapery. Once you are satisfied with the shape of the figure you can begin to explore the way the material hangs from particular areas of the body. Don't overwork the folds and gathers of the drapery

Sketching figures

People always make engaging studies. A good way to gain confidence in drawing people is with a sketchbook: make quick sketches of seated figures on buses or trains and note how their clothes hang and serve to accentuate the way they sit.

or the image will look stiff and unnatural.

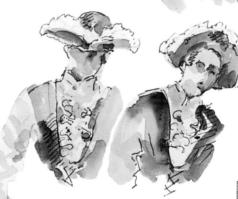

Moving figures

If you draw repeated studies of a moving figure, use a fast medium such as pencil or pen and watercolour to capture the most interesting features: look for the way their clothes behave as they twist and turn.

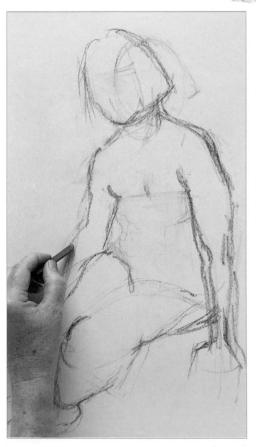

The folds made by drapery create interesting patterns on and around this figure. Draw the proportions of the woman in first with charcoal on lightly toned pastel paper, reducing the image to a series of simple shapes. Repeat lines or change the angle of the head until you have an accurate rendering of the figure.

Loosely block in the essential features and skin colouring of the figure with soft pastels until you have achieved a reasonable human likeness. Then concentrate on describing the varying rhythms and tones of the different materials.

3 Praw in the deep folds created by the drapery thrown over the seat, looking to see how it hangs and catches the light. You will need to use quite a wide range of green pastels to recreate the strong lighting effects, so first establish the shapes of the drapery in one colour.

 6° Draw in the finer details of the figure with a pastel pencil; a slightly harder version of a soft pastel in a pencil format. This will allow you to work more precisely on smaller areas such as the face, capturing the final highlights and emphasizing any particular features.

Malaysian Woman in a Sarong

This richly coloured study of a figure gives a strong visual description of the nature of drapery and the way it can echo and enhance the rhythms of the human body. The blended pastels on her sarong illustrate how the light strikes her body and gives it form, while layers of dark pastel on the bench fabric create the effect of a heavier, thicker cloth falling to the ground.

The shape of this figure is simple yet strong enough to give a solid image on which to draw the hanging material.

The irregularity of the red pattern helps to identify the contours of the body and creases in the material.

Bold lines of dark colour have been used for the deepest folds of cloth while the lightest tints pick up the direction of the strong light source. 4 Build up the tones of the woman's sarong, using dark colours for the deepest creases that help to shape her body. Then pick out the red pattern of the cloth and observe how its regularity is disrupted by folds or contours.

5 Use a deep blue pastel and charcoal for areas of fabric that cast the strongest shadows. This will give the material an intense, heavy feel and a sense of depth.

Main materials

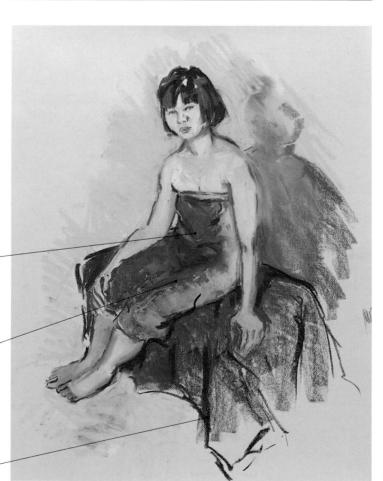

Pastel pencil

Sue Sareen

Life Drawing

The human body is generally thought to contain every aspect of form, visual complexity, and subtlety that an artist will encounter. Drawing a human figure regularly will help you to improve your powers of observation and drawing skills, but it is often hard for artists to find people willing to devote their time to sit as models. By joining a life drawing class you can take your time to study figures and to glean different ideas and techniques from observing other artists. While you should learn to pay attention to the anatomical proportions of the human body, a life drawing class will also allow you the freedom to express a mood in the way a model sits or stands, or a certain characteristic feature in their personality.

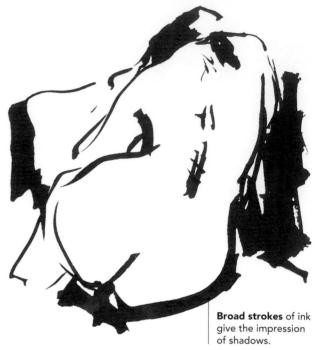

Five minute pose

This decisive yet eloquent study of a woman's back shows how a few expressive lines and the minimum of detail can create a convincing image. The study was drawn with a Chinese brush and ink which encourages a lyrical style full of control.

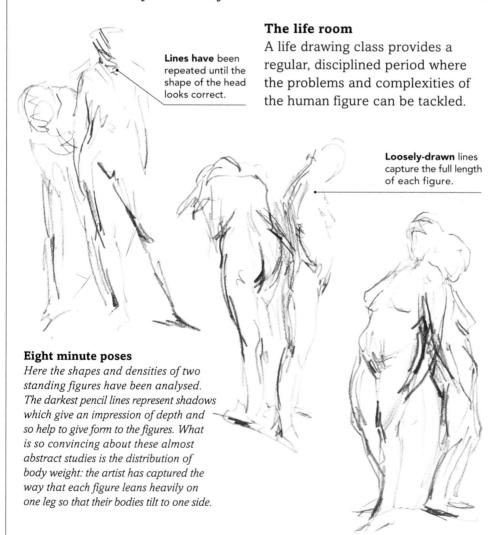

In order to get to know the different aspects of a model it is useful to begin with a series of exercises that test your powers of observation rather than your ability to draw a lifelike figure.

By getting a model to do a series of timed poses, from five minutes through to several hours, you can develop a range of strategies and approaches in which to analyse and interpret the human figure. The quickest drawings of five minutes or less require a very swift, gestural style: you have to capture the essence of the model's stance by looking carefully for the strongest shapes and then distilling them into an impressionistic image. The most important aspect of this exercise is to draw the whole length of the figure and not waste time concentrating on incidental details.

Ten and fifteen minute poses still demand a certain speed, but they allow you to develop your style beyond the purely gestural. Take this extra time to look for the dynamic angles and planes of the body. Look also for the way the model sits or stands and affects the distribution of weight through the body, using a plumb line if necessary to determine the balance of the figure in relation to a true vertical line. With any short pose it is important to develop the drawing only as far as the time will allow and not to over-emphasize any individual characteristics.

Taking thirty minutes to an hour to draw a figure will give you the chance to develop more intricate

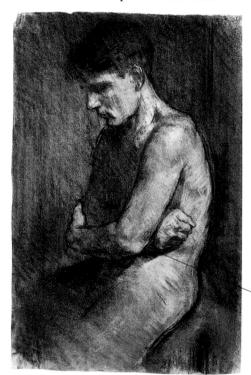

Two hour pose

With more time to study his personal character, the artist has explored the mood of this man and generated a strong atmosphere of brooding contemplation. The wide range of tonal values drawn in charcoal gives the figure solidity, while the weight of his body pulls downwards to give a forceful sense of gravity.

Four hour pose

Subtle blending and a powerful perspective give this drawing a sensuous yet controlled feeling. The artist has taken his time modelling the figure, picking out the highlights with care so that the final impression is of a woman bathed in suffused sunlight. The treatment of the bed and the highlights that have been produced with an eraser add to the softness of the scene.

aspects of character and study the form of the body in some detail. Work up a series of tones with solid shading or cross-hatching and hatching to give the body a sense of depth and volume.

With poses of two hours or more, a different process evolves. The proportions of the body are more significant so use the size of the head as a basic unit of measurement. The body should be approximately seven and a half times larger than the head. Think also about the light source: enhanced or distorted effects created by the light as it shines from different angles can create a fascinating study. Look for the patterns made by shadows across the body, how some areas of the body are plunged into obscurity while other muscles or features are accentuated by an intense bright light. Describing the surroundings at this stage will help to put the figure within a more realistic context.

The contrast of strong

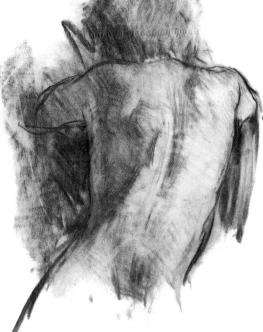

One hour pose

Here the light hitting the back of the body illuminates some of the many planes and facets of the human figure. Such dips and curves caused by muscles and bones beneath the skin are important to depict as they give substance to the study. Although the shading is roughly executed, the effect gives a rugged realism.

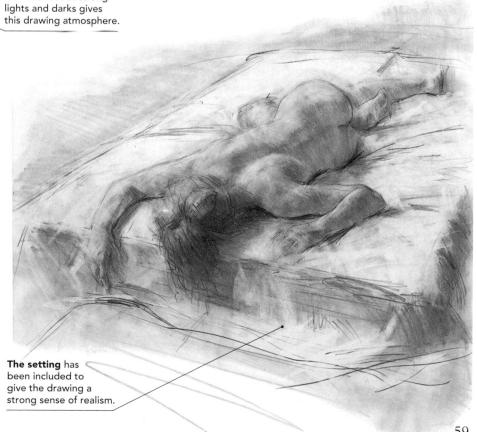

PORTRAITS

The Need to depict a person's individual characteristics sets portrait drawing apart from figure drawing. The best approach to take when you draw a portrait is to study the construction and form of the head, noting the proportions of particular features in relation to the size of the face. You may like to experiment with the lighting to create an atmosphere or reflect the mood of the sitter and such unusual effects may help you to look at your subject in a fresh way. If you need to gain practice capturing a human likeness, try drawing a self portrait so that you can study at your own leisure.

Capturing a mood

Often the medium you use will reflect the mood of the sitter. A bold, heavy drawing in charcoal may signal an angry or defiant mood, a pencil drawing will enable you to describe a range of tones to give dimension to a portrait, while a delicate pen and ink drawing can pick up the subtle nuances of a person's character.

Lighting

Lighting can radically affect the appearance of an individual. A full light shining straight on to the face will flatten the features and give you little chance to explore the depth of the head. Light shining on the side of the head creates a more interesting study, but if you want to exaggerate someone's personality or create an unsettling effect, try lighting them from below.

Proportions

To draw a portrait successfully, you need to be able to produce a solid, lifelike image of a head with recognizable features that identify the sitter. Work out the symmetry of the face by dividing it roughly into three equal parts. The top section is from the crown to the brow; the central section is from the brow to the end of the nose; and the bottom section is from the end of the nose to the bottom of the chin. Draw the eyes approximately one-eye's width apart and measure the triangle made by the eyes and the end of the nose as these are important features and define the particular shape of the face most accurately.

Self portrait

Self portrait studies are a good way to practise drawing human features, although they often portray a rather confrontational gaze as a result of you staring at yourself in the mirror. Select the most essential and interesting features as you draw – if you attempt to capture every detail you may end up with an overworked drawing.

Pset up a mirror in a convenient place so that you can see yourself easily and, if possible, where the light will cast shadows for an interesting effect. Sketch the shape of your head and features in pencil on a broad sheet of textured paper, keeping the drawing as large as possible.

Block in the main areas of the face and hair with oil pastels, applying each colour loosely to cover the paper effectively. Oil pastels give a rich, colourful effect and adhere to the paper easily. Use a cloth dipped in turpentine to wipe away mistakes or colours you may want to change.

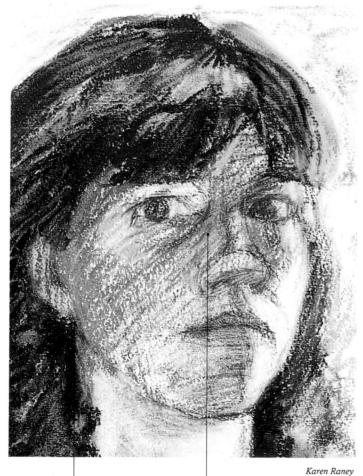

Yellows and oranges have been used for warm lights, and cool mauves and greys for areas in shadow.

Self Portrait Study

Oil pastels give this self portrait a richer, deeper effect than would ordinary pastels. The slight transparency of the oil pastels also allows separate lines of overlaid colour to create an optical mix. The size of the paper is significant in giving the artist more confidence to draw boldly and capture the strong lighting effects cast across the side of her face.

3 • Use a finger or a piece of material to blend pastel marks together if you want to give a smoother texture to some areas of skin. Make sure the pastels are soft so that you can blend them easily on paper.

Figures in a Setting

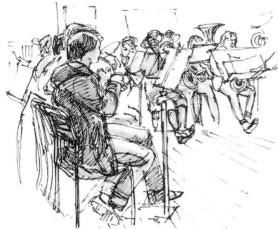

Describe a background with just a few suggestive lines

Establishing a focal point

The human eye is similar to a camera lens in that it cannot focus on everything at once, so you will need to work systematically to establish the figure as a focal point first and then go on to develop the background scene.

I b Sketch the figure lightly first in pencil on a toned, semi-rough watercolour paper. Then draw in the fountain and the most prominent features of the buildings. Once you have all the proportions drawn correctly, return to the figure and strengthen the image.

FIGURES ARE RARELY SEEN in isolation – usually they are situated against a backdrop, either indoors or outside. Invariably this background is a significant element in a drawing, but the most important thing to remember is that you should always relate the figures to their surroundings. The interaction between the two needs to be organized carefully within a composition to give a strong sensation of depth and create a series of spatial relationships. Try not to include too much background detail so the emphasis of the drawing remains centred on the figures.

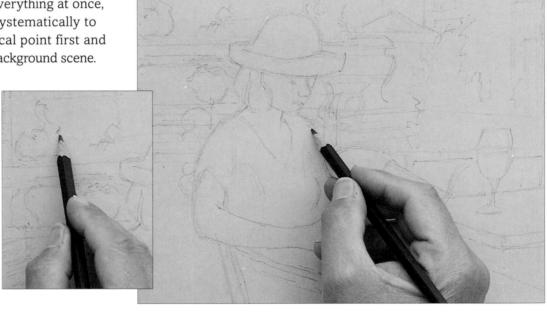

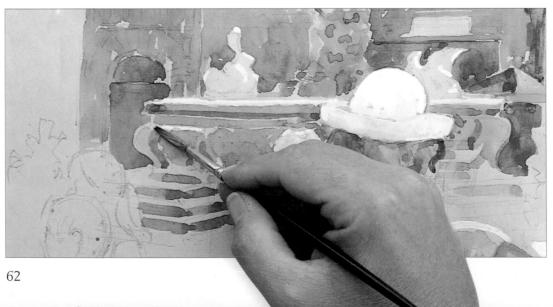

As this café scene is situated outside in a square, the quality of light is much stronger, casting short dark shadows and producing bright highlights. Mix some cool washes of watercolour for areas of the fountain and buildings that are in shadow and apply them with a small sable brush.

Represent the way the light defines the form of this figure with dark transparent washes for shadows and white gouache for the highlights. White gouache is essential for describing strong light and pale colours if you are working on toned paper. Redefine details such as the hat with a pencil. These subtle lines will give a better sense of form and shape and help to push the figure further into the foreground.

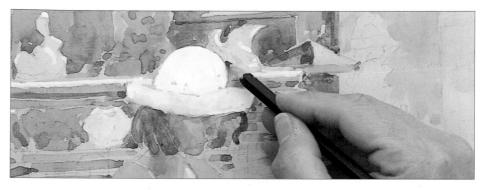

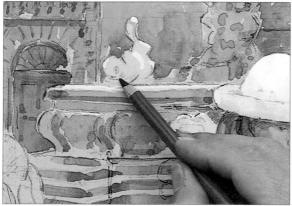

4 • Use a charcoal pencil to delicately shade small features such as the stonework on the fountain. This refined form of charcoal retains the dark, heavy quality of the medium, while the pencil format allows you a greater degree of control and precision.

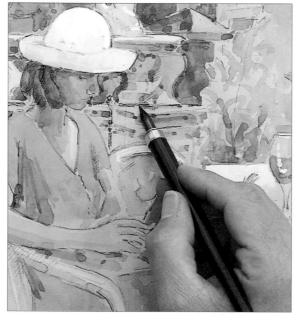

5 «Use a dip pen and black ink to draw in the final details, redefining any pencil marks that may have been covered by the washes of colour.

Materials

Town Square

This figure and the setting behind her both complement and balance one another; the figure blends into the scene while still looking prominent enough as a focal point. The scale of the background also relates proportionally to the figure and the light cast across the whole scene links individual features in a series of strong tonal contrasts.

The shape of the girl's hat provides an interesting feature against the fountain in the background.

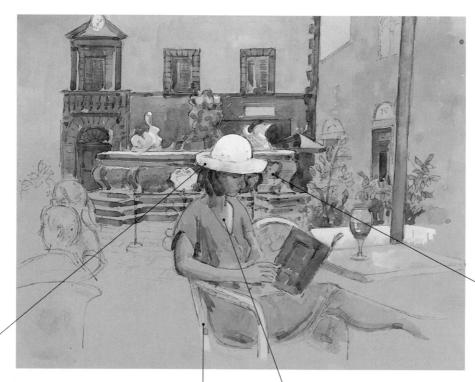

Opaque highlights are used to give a feeling of hot, bright light, while dark, transparent hues describe the short shadows of early afternoon.

Our attention focuses primarily on the girl and then on the different features beyond.

The strong sense of perspective gives the impression of a large area of space between the figure and the fountain.

James Horton

Gallery of Figures

LIGURES HAVE ALWAYS been a fascinating Γ subject matter for artists; after all, almost everyone is aware of, perhaps even intrigued by the people around them and how they move and act. To draw figures successfully and understand your subject, you must capture not just the right proportions and shape of a human body, but the character of an individual. Details that may only be subconsciously observed on an everyday level, such as the colour of someone's eyes or the way they dress, can be deliberately exaggerated in a drawing to transform the personality of a figure and emphasize their character. What all of these artists have achieved in their work is a convincing portrayal of human life that encapsulates each individual succinctly.

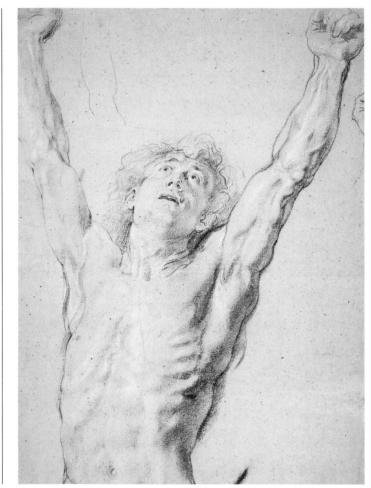

Rubens, Study of a Crucified Man,

c.1614-15, 53 x 37 cm (21 x 14½ in)

This work in brown chalk is typical of the many studies Rubens would have made in preparation for a painting. Rubens used the drawing to familiarize himself with every aspect of this man's torso, bringing out the complexities of human form with remarkable subtlety. He describes the contours of the body and the muscles on the chest with precise yet evocative lines. His use of brown chalk is actually quite sparing and understated, though the tone of the paper and white chalk highlights generate a strong feeling of solidity.

58 x 41 cm (23 x 16 in)
This portrait brings out the character of the sitter most sensitively. While not making a particularly detailed study, the artist has conveyed the personality of this figure effectively with small details such as her posture and the position of her feet. The addition of colour reinforces the loosely drawn image and accentuates the slumped position of this woman in her chair.

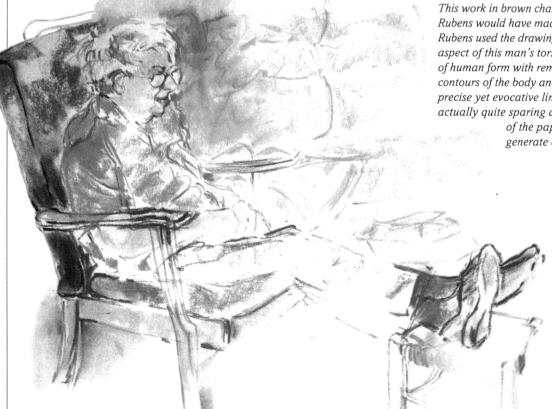

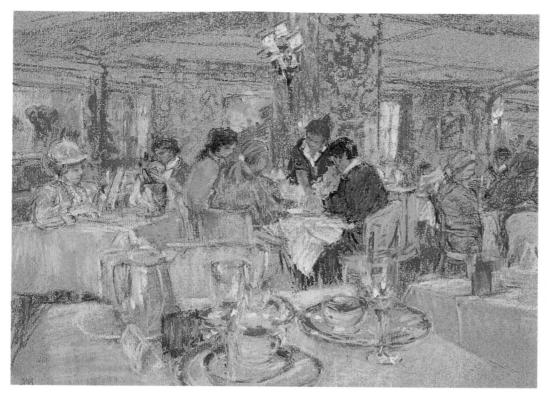

Diana Armfield, RA, Studying the Menu at Fortnum's, London,

44 x 27cm (171/2x 101/2 in) In this pastel drawing the artist has cleverly arranged her composition so that the focus of attention is actually on the group of figures in the middle distance, in spite of the spacious foreground. The lack of finished detail in the foreground helps to lead the eye straight to the tables of seated customers, who appear more dominant than they really are. Although these figures are relatively small, their movements have been thoughtfully described and there is even a suggestion of their characters. Most importantly, they appear very much part of their environment, giving the work a strong sense of unity.

Norman Blamey, RA, St Andrew, Fisher of Men, 36 x 23 cm (14 x 9 in)

This work is a study for a mural and the drawing has been squared up ready to be transferred on to a wall. The most noticeable aspect of this study is the high viewpoint the artist has chosen. The rapid descent towards the foot, and the arms that appear too long for the body, are caused by an acute foreshortening of the whole figure. Again, Blamey has assiduously explored and studied his figure to create a profoundly fascinating drawing.

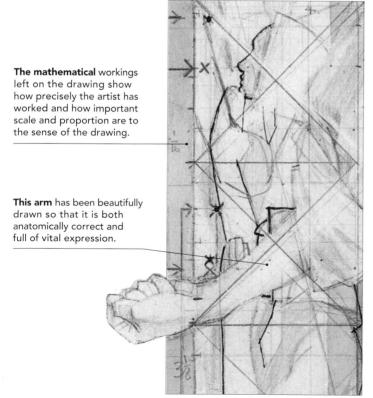

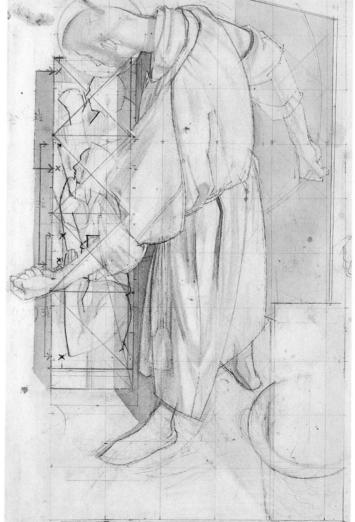

Movements & Gestures

ONCE YOU HAVE gained confidence drawing people sitting still for you in a controlled environment, try drawing a scene full of movement and vitality. This type of subject matter requires a different approach as you need to be able to memorize a certain

amount of information every time you look away from the scene, since it will change constantly.

This process depends upon assessing a fluctuating image and distilling it before you begin to draw. Dancers or animals are good subjects to begin with as they often repeat movements or gestures, but try to adopt a loose style so that you can capture the essence of an image quickly. Working in this way, your drawings should have a freshness

and immediacy that is difficult to achieve in a regulated situation.

Suggesting movement

The speed at which you need to draw a moving image means that you have to be adept at suggesting information and giving clues with the minimum of linear marks and shading. The best media to use for such fast work are those that enable you to cover the paper swiftly, such as watercolour or pastels.

Study animals such as lions and tigers and notice how they move.

Dancers, with their ability to move gracefully and powerfully, make fascinating subjects.

The Choose a richly toned blue Ingres paper and capture this atmospheric evening scene on a balcony as quickly as possible with charcoal, reworking any lines swiftly and repeatedly until you are happy with the positioning of the figures.

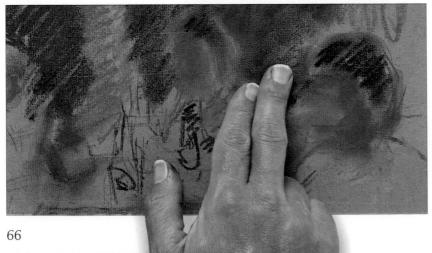

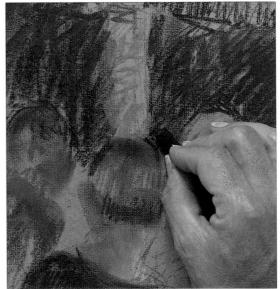

As this scene is full of movement and fleeting impressions, use your imagination to select interesting colours. Note any areas illuminated by the light with a bright orange-yellow pastel and loosely block in the background with deep, rich blues and purples.

3 To give a more impressionistic, hazy feel to the background, merge the blue and purple pastels by smudging the colours together gently around each figure with your fingers. Be sure to wash your hands after to avoid soiling the drawing.

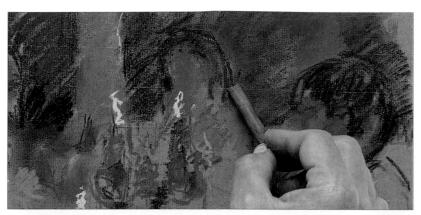

4 Build up the form of each seated figure with a series of dark tones, using charcoal to redefine any outlines against the dark background. Try to capture the position or stance of the five diners – whether they are resting their elbows on the table, or leaning on the armrest of their chair – rather than attempting to discern facial expressions and small details.

Main materials

Selection of pastel colours

Once you have drawn in the main source of light, use a combination of light green, warm red, and deep yellow to pick out the soft highlights on each figure with loosely hatched marks.

5 $\stackrel{\blacktriangle}{=}$ As these figures all face one another around a table, they should be linked by a focal point to give the composition some unity. The bright, magnetic light of the candles in the middle of the table provides this focus, so use a pale, bright pastel colour to delineate the flickering flames.

Evening Meal on a Balcony This night scene is full

This night scene is full of fleeting impressions and suggested movement. Only the essential facts have been recorded with a series of gestural lines based upon a few glances and a good visual memory. The lack of attention to detail gives this impressionistic study a shifting rhythm and strong sense of mass.

Soft highlights help to model the form of each figure.

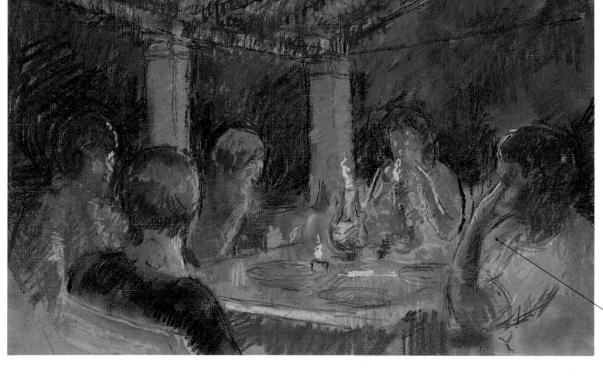

James Horton

Analyzing the subject In the charcoal work above, the artist John Ward has studied the anatomy of this figure intently so that he can describe her perfectly in "Zandra Rhodes Dress" (right).

Drawing for Painting

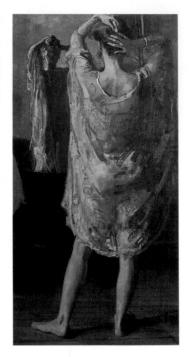

▼ISTORICALLY, THE MAJORITY of artists' Harawings were used solely as studies for later paintings. They were a means to an end rather than an end in themselves. Although drawing now has a much higher status and is accepted as an art form in its own right, drawings are still often used as preparatory studies for other works. A drawing, or a series of drawings, can help you familiarize yourself with your subject matter, investigating, for example, the play of light and assimilating all the information so that you have a precise visual reference as you paint. You can also combine several preparatory drawings into one painting by tracing each individual study and linking them in a strong composition.

Collating information

Making preparatory drawings for a painting is a good method of testing imaginative ideas visually on paper before you commit yourself to canvas. The images below are a mixture of sketches and detailed drawings that were drawn at different times. By scaling the figures down and trying them out in different areas of the room setting, you can establish where they work best to create the most harmonious relationship. If you include several separate drawings in one composition, you can prevent them from looking superimposed by making subtle tonal adjustments as you paint.

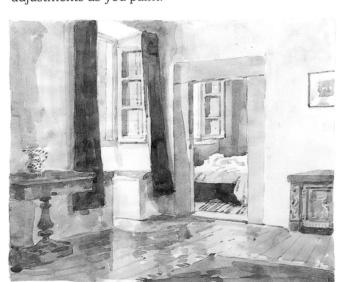

Seated girl at a window In this pen and wash study the light hits the girl from the same direction as it does the standing figure. This creates a clear link between the two.

Standing figure Figures should relate to their surroundings, so this image should be scaled to an appropriate size to look realistic within the interior.

Interior study

The essential details of this scene and the light streaming through the windows provide a good visual reference for a painting.

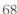

Creating a composition

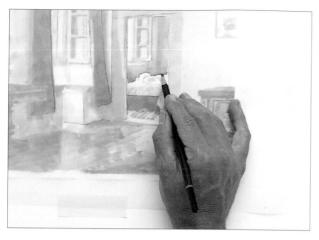

■ Begin by copying Begin by copying the basic outlines of the interior study on to tracing paper with a soft pencil, keeping the sketch simple and well-defined. Secure the tracing paper down with masking tape to prevent it moving.

> ▶ Scale down any 2 image that is too large. Then trace around the outline of each figure.

▶ Position the trace of the standing figure over the original interior watercolour study, moving it around until a suitable composition begins to materialize.

◀ Transfer all 4 the tracings on to paper, either by heavily shading the opposite side of the tracing paper and drawing the image again, or by using carbon paper.

Materials

6B pencil

5 Once you have drawn in all the images, add in the remaining features and details to give a comprehensive scene that can be transferred to canvas.

Tracing pape

Establishing a Scene

The artist has successfully placed these two figures in a strong composition in preparation for a detailed painting. Each figure has been accurately scaled to look realistic within the interior setting.

Each figure has been placed in an appropriate part of the setting.

The most relevant information has been included to give the composition clarity and interest.

James Horton

Masking tape

69

GLOSSARY

ABSORBENCY The degree to which the paper absorbs the paint, often due to the amount of surface sizing.

ACID-FREE PAPER Paper with a neutral pH that will not darken excessively with age (unlike acidic bleached wood pulp).

AERIAL PERSPECTIVE The effect of atmospheric conditions on our perception of the tone and colour of distant objects. As objects recede toward the horizon, they appear lighter in tone and more blue.

BINDING MEDIUM The substance that holds pigment particles together and attaches them to a surface. Water-soluble gum is used for soft pastels, wax for crayons, and oil for oil pastels.

BLENDING A soft, gradual transition from one colour or tone to another using either a torchon or a finger to smudge the colours together.

BLOCKING IN Laying in a broad area of colour.

BODY COLOUR Also called gouache. A type of watercolour paint characterized by its opacity.

BRACELET SHADING A form of shading in which semi-circular lines are repeatedly drawn close to one another.

CHARCOAL Willow, vine, or other twigs partially burnt and carbonized in airtight containers.

COLOURED PENCILS Wax-based crayons in a pencil format and available in a wide selection of colours.

CONTÉ CRAYON Chalk-based pastels with a square cross-section that are midway between soft and hard pastels in texture. Sold in a range of up to 80 colours.

CROSS-HATCHING Parallel marks overlaid roughly at right angles to another set of parallel marks.

EASEL A frame for holding a drawing while the artist works on it. Artists working outdoors tend to use easels of light construction. A good sketching easel allows the drawing to be held securely in any position from horizontal to vertical.

ELLIPSE A circle whose apparent height appears to diminish the further it tilts away from you.

ERASER A tool for removing pencil and other marks. In the past artists used rolled bits of bread or feathers. More recently artists have used standard rubber erasers, soft putty erasers, or artgum erasers, although the new plastic erasers are extremely clean and versatile.

FEATHERING Laying roughly parallel marks, often over a previous area of colour, to modify the strength of colour or tone.

FIXATIVE A resin dissolved in solvent which is sprayed on to a drawing to fix the particles to the surface.

FORM The shape of a three-dimensional object, usually represented by line or tone in a two-dimensional drawing.

GranuLation The mottled effect made by heavy coarse pigments as they settle into the hollows of the paper.

Graphite Pencil. Standard pencils are made from a mixture of graphite and clay that is encased in wood. The mixture is initially fired and subsequently impregnated with molten wax. The proportion of graphite to clay varies and it is this which determines the hardness or softness of the pencil. Graphite has a "silvery" or metallic sheen if used densely.

GRAPHITE STICK A thick graphite pencil used for large-scale work that is fixed in a graphite holder rather than encased in cedarwood.

HATCHING Making tonal gradations by shading with thin parallel marks.

HIGHLIGHT The lightest tone in a drawing.

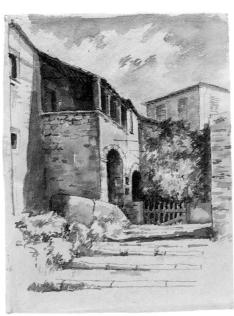

Watercolour study

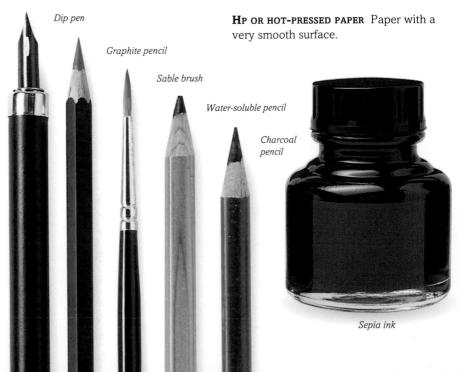

HUE Describes the actual colour of an object or substance as it would appear on the colour wheel.

LIFTING OUT Modifying colour and creating highlights by taking colour off the paper using an eraser or sponge.

LINEAR PERSPECTIVE The method of representing a three-dimensional object on a two-dimensional surface. Linear perspective makes objects appear smaller as they get farther away by means of a geometric system of measurement.

MODELLING Describing the form of a solid object using solid shading or linear marks.

MONOCHROMATIC Drawn or painted in shades of one colour.

Not or cold-pressed paper Paper with a fine grain or semi-rough surface.

OAK GALL INK Ink made by crushing and boiling oak galls. The galls are formed by parasitic insects living off oak trees and tend to appear in Autumn.

OIL PASTEL Pastel bound by oil as opposed to gum. The oil gives this type of pastel a slight transparency and a strong adherence to the support. It comes in a less extensive range than soft pastels.

OPAQUE COLOUR See Body colour.

OPTICAL MIX When a colour is arrived at by the visual effect of overlaying or abutting distinct colours, rather than by physically mixing them on a palette.

Plum line

ROUGH OR COLD-PRESSED Paper with a rough surface.

SABLE Mink tail hair used to make fine watercolour brushes.

SGRAFFITO A technique, usually involving a scalpel or sharp knife, in which dried paint is scraped off the painted surface. Often used for textural effects.

Shading Usually refers to the way areas of shadow are represented in a drawing and is invariably linked with tone.

Sight size The measurement of the size of a distant object as you see it which is then transferred exactly to the paper.

SILVERPOINT A method of drawing whereby a fine piece of silver is dragged over a piece of prepared paper. Chinese White watercolour provides a matt surface to which the tiny particles of silver adhere.

SOFT PASTEL The original and most common form of pastel. The weak solution of gum used in their manufacturing ensures a very soft texture.

STIPPLING A method of drawing whereby tiny dots of colour are applied close together to create an area of tone.

Surface The texture of the paper. In Western papers – as opposed to Oriental – the three standard grades of surface are rough, semi-rough (cold pressed or NOT), and smooth (hot-pressed or HP).

TECHNICAL PEN A relatively recent innovation in which the tip of the pen is hard and inflexible and designed to give a consistent width of line regardless of the pressure placed on it.

TONE The degree of light reflected from a surface.

VIEWFINDER Two L-shaped pieces of card that form a framing device. This is usually held at arm's length and the scene to be drawn can be seen through it.

Wash A layer of colour, often uniform in tone, applied across the paper with a brush.

WATERCOLOUR A quick-drying paint made from ground pigments and a water-soluble binding medium such as gum arabic. The medium is characterized by its luminosity.

WAX RESIST The process by which wax crayons are used to protect areas of the paper when watercolour paint is applied.

WEIGHT Watercolour paper is measured in lbs (pounds per ream) or gsm (grams per square metre). It comes in a large range of weights, although the standard machinemade ones are 90lb (190 gsm), 140 lb (300 gsm), 260 lb (356 gsm) and 300 lb (638 gsm). The heavier papers, 260 lb and over, generally do not need stretching.

A NOTE ON MATERIALS

- Avoid using Chrome colours when you work with watercolour as they carry a significant health risk. There is no danger with any other pigments, provided artists take sensible precautions and avoid licking brushes with paint on them.
- Soft pastels generate a good deal of dust so it is best to avoid inhaling the pigment powder as far as possible. If you are working indoors, make sure the room is well ventilated.
- The brush sizes given in this book refer to Winsor & Newton brushes. They may vary slightly from those of other manufacturers.

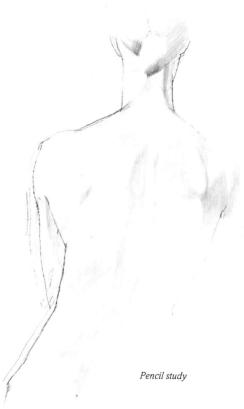

<u>Index</u>

acid-free paper, 24 acrylic gesso, 26 aerial perspective, 30, 47 animals, 50 architectural drawings, 44-5 Armfield, RA, Diana, 65 atmosphere, portraits, 60

backgrounds, 30 figure drawings, 62-3 bamboo pens, 14 Baroque, 40 beachcombing, 50 Bell, Richard, 51, 54 Blamey, RA, Norman, 65 blending tools, 19 body colour, 20 Boudin, Eugène, 49 bracelet shading, 36, 37 Bruegel, Pieter the Elder, 8, 9 brushes, 20 architectural drawings, line drawings, 34

buildings, 44-5

Butlin, Anne-Marie, 49

C Canaletto, 9 canvas rolls, 21 Caravaggio, 9 carbon paper, 69 cartridge paper, 24, 28, 35 cave paintings, 8 Cézanne, Paul, 22 chalk pastels, 18 chalks, 16-17 gallery, 23 keeping work clean, 47 paper, 26 charcoal, 16 capturing a mood, 60 line drawings, 34 charcoal pencils, 16 Chinese ink, 15 clothes, 56-7 coloured inks, 15 coloured paper, 24, 27 coloured pencils, 12-13, 36 aerial perspective, 30

optical mixing, 13, 36

composition, 42-3

drawing for painting, 68-9 figures in a setting, 62-3 gallery, 48-9 interiors, 46-7 landscapes, 52-3 Constable, John, 10 Conté crayons, 16, 17 craft knives, 13 crayons, 16-17, 19 cross-hatching, 13, 36, 67 crustaceans, 50-1 cubes, 32

D
deconstructing images, 43
Degas, Edgar, 10, 11
Delacroix, Eugène, 10
dip pens, 14
drapery, 56-7
drawing boards, 21
drawing chalks, 16
drawing clips, 21

E ellipses, 32-3 equipment, 13 erasers, 13, 38-9 eye level, 31, 44

F feathering, 36, 37 fibre-tipped pens, 15 figure drawing: drapery, 56-7 drawing for painting, 68-9 gallery, 64-5 life room, 58-9 movements and gestures, 66-7 setting, 62-3 fixative, 13, 19, 21 focal points, 62 foreground, 30 foreshortening, 32 form, 36-7 gallery, 40-1 tonal drawing, 38-9 fountain pens, 14 Fouquet, Jean, 12 Fraser, RA, Donald Hamilton, 41

Gallwey, Kay, 27 gesso primer, 26 gestures, 66-7 gouache, 20, 27 graphite pencils, 12 graphite sticks, 12 guidelines, 33 gum arabic, 15

H
Harris, Jon, 48
hatching, 36, 37, 67
highlights, 38-9
history, 8-11
Hockney, RA, David, 11
Holbein, Hans, 8
horizon line, 31
Horton, James, 45, 47, 67
Horton, Percy, 27, 55
human body see
figure drawing

I Indian ink, 15 Ingres, Jean Auguste Dominique, 10 Ingres paper, 24, 27 inks *see* pen and ink interiors, 46-7, 68-9

John, Augustus, 11 K kitchen roll, 53 knives, 13

L landscapes, 52-5 layout, 42-3 "lead" pencils, 10, 12 Leonardo da Vinci, 54 Lewin, Paul, 41, 55 life room drawing, 58-9 light architectural drawings, changing effects of, 30 drawing for painting, 68 interiors, 46-7 modelling, 36 portraits, 60 tonal drawing, 38-9 linear drawing, 34-5 linear perspective, 31

M masking tape, 69 Matisse, Henri, 10 measuring, 42 Michelangelo, 8, 40 middleground, 30 mirrörs, self portraits 61 mixed media, 22, 29 modelling, 36-7 monochrome, 38 mood, portraits, 60 movements, 66-7

N natural forms, 50-1, 54-5 Newbolt, Thomas, 40, 48 nibs, 14-15

Oak gall ink, 15 observation, 30 oil pastels, 19, 22 optical mixing, colour, 13 outdoor drawing, 21

P painting, drawing for, 68-9 paints, watercolour, 20-1 paper: choosing, 28-9 gallery, 26-7 sketchbooks, 25 transporting, 21 types, 24 pastels, 18-19 gallery, 22 keeping work clean, 47 paper, 24, 26 shading, 36 pen and ink, 14-15 architectural drawings, 44-5 capturing a mood, 60 line drawings, 34, 35 mixed media, 20, 29 paper, 26 shading, 37

pencils, 12-13 capturing a mood, 60 charcoal, 16 gallery, 23 history, 10 mixed media, 29 pastel, 18 techniques, 28

techniques, 28

perspective: aerial, 30, 47 buildings, 44 composition, 43 landscapes, 52 linear, 31 plants, 50 plum lines, 43 Pontormo, Jacopo da, 8 portraits, 9, 10, 60-1 preparatory drawings, 68-9 primer, 26 proportion: buildings, 44 portraits, 60 putty erasers, 13, 38-9

quill pens, 14

R

R Raney, Karen, 22, 26 raw sienna ink, 15 recession, 44 reed pens, 14 Rembrandt, 8, 9, 26, 28 Renaissance, 8, 12, 40 rollerball pens, 15 Rubens, Peter Paul, 9, 64

S sable brushes, 20, 45 sanguine, 16 Sareen, Sue, 57, 64 self portraits, 61 sepia ink, 15 sgraffito, 19, 36 shadows: modelling, 36-7 tonal drawing, 38-9 shapes, 32-3 architectural drawings, 44 form and modelling, 36-7 tonal drawing, 38-9 sharpeners, 13 shellac, 15 'sight size" technique, 42 silverpoint, 12 sketch pens, 15 sketchbooks, 30, 31 figure drawing, 56 making, 25 watercolour, 20

Spencer, Stanley, 11

sponges, 17

Stanton, Jane, 23, 49 still life: forms, 33 linear drawing, 35 tonal drawing, 38 stippling, 36 stools, 21

T
technical pens, 14, 15
texture:
architectural drawings,
44
paper, 24, 26, 29
Tiepolo, Giambattista, 9
tonal drawing, 38-9
toned paper, 24, 26, 27
tones, modelling, 36
tortillons, 19
tracing paper, 18, 69
Turner, RA, Joseph
Mallord William, 10

V Van Dyck, Sir Anthony, 54
Van Gogh, Vincent, 11
vanishing point, 31, 44
Velazquez, Diego
de Silvay, 9
Vermeer, Jan, 9
viewfinders, 42, 52
viewpoints, 31

W

Ward, RA, John, 23, 68 washes, watercolour, 20 water-soluble pastels, 19 water-soluble pencils, 12, 13 watercolours, 20-1 gallery, 22-3 landscapes, 52 mixed media, 29 monoprints, 65 paper, 24, 26-7 shading, 36 techniques, 28, 29 toned grounds, 48

ACKNOWLEDGEMENTS

Author's acknowledgements

James Horton would like to thank all the artists who have contributed to this book, especially those who entrusted their drawings into my safekeeping. Thanks also to the photographers at the DK studio whose helpfulness and cheerful nature made every photo session a happy occasion. Particular thanks to Steve Gorton whose patience and professional skill made sure that the location shoot in Tuscany was successful. Thanks also to everyone at DK who worked on the book.

Picture credits

Key: t=top, b=bottom, c=centre, t=left, r=right, a/w=artworks, RAAL= Royal Academy of Arts Library

Endpapers: Jane Gifford; p2: John Ward, RA, RAAL; pp 6/7: a/w James Horton; p8: t Pontormo, Uffizi, Florence/Ikona; b Holbein, Staatliche Kunstsammlungen Dresden; p 8/9: c Canaletto, Courtauld Institute Galleries; p9: t Breughel, Hamburger Kunsthalle; b Rembrandt, Albertina Graphische Sannlung; p10: t Constable, Victoria and Albert Museum/Bridgeman Art Library: c Delacroix, Louvre, Paris/ Réunion des Musées Nationaux; p11: t Degas, Tate Gallery, London; bl Van Gogh, Gift of Miss Edith Wetmore, 1960-232-1, Courtesy of Cooper-Hewitt, National Museum of Design, Smithsonian Institution/Art Resource, NY; br Spencer, by courtesy of the National Portrait Gallery, London, © Estate of Stanley Spencer 1994 all rights reserved DACS; p12: Fouquet, New York Metropolitan Museum/ Visual Arts Library; p20: a/w James Horton; p22: t Karen Raney; b Cézanne, Kunsthaus Zurich; p23: t John Ward, RA, RAAL; b Jane Stanton; p26: t Rembrandt, The British Museum; b Karen Raney; p27: t Kay Gallwey; b Percy Horton; p28: t

Jason Bowyer; cl Percy Horton; br Neale Worley; p29: tr William Wood; b Neale Worley; p31: a/w Neale Worley; p32/33: all James Horton; p34: tr Sue Sareen; c Neale Worley; b Richard Bell; p36: tl Norman Blamey, RA; br James Horton; p37: all Sharon Finmark; p40: Michelangelo, Graphische Sammlung Albertina, Vienna; b Thomas Newbolt; p41: t Paul Lewin; b Donald Hamilton Fraser, RA, RAAL; p42: all James Horton; p 44: a/w James Horton; p48: t Thomas Newbolt; b Jon Harris; p48/49: Boudin, Marmotton Museum/Dorling Kindersley; p49: tr Jane Stanton; c l Anne-Marie Butlin; p54: b Richard Bell; p54/55 Van Dyck, The British Museum; p55: t Percy Horton; b Paul Lewin; p56: a/w James Horton; pp 58/59: all Neale Worley; p60: tl Karen Raney; rest William Wood; p62: tl a/w Richard Bell; p64: t Rubens, The British Museum; b Sue Sareen; p65: t Diana Armfield, RA; b Norman Blamey, RA; p66: a/w James Horton; p68: t John Ward, RA; rest James Horton; p70: bl James Horton.

Dorling Kindersley would like to thank: Ruth Kendall for her help and Steve Gorton and his excess baggage for helping to make the Italian photo shoot possible.